DIRECTOR'S CHOICE
THE MORGAN LIBRARY & MUSEUM

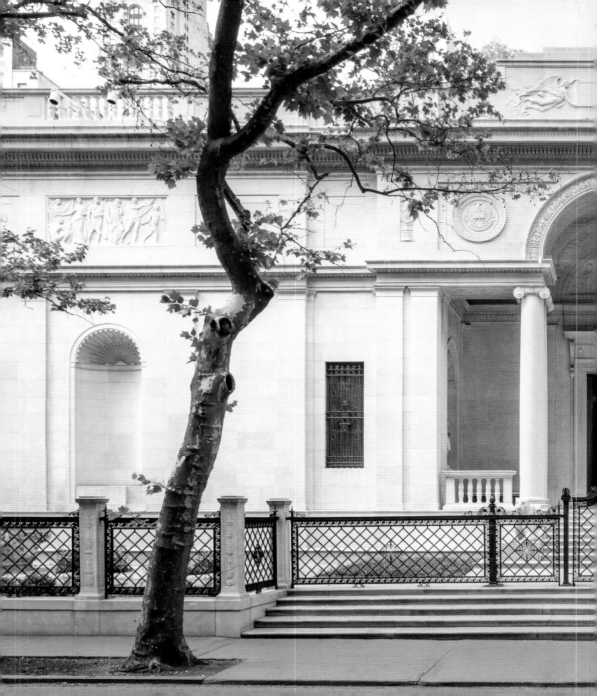

DIRECTOR'S CHOICE

THE MORGAN LIBRARY & MUSEUM

Colin B. Bailey

SCALA

INTRODUCTION

THE MORGAN LIBRARY & MUSEUM occupies some 150,000 square feet in a sequence of buildings with a public entrance on New York's Madison Avenue, between 36th and 37th Streets. It comprises four main structures, built between 1906 and 2022. At its heart is the historic Library commissioned in 1902 by the founder, American financier and investment

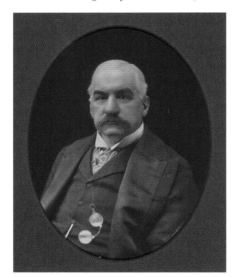

John Pierpont Morgan, ca. 1902

banker John Pierpont Morgan (1837–1913), from the firm of McKim, Mead & White. The library was intended to house Morgan's growing collection of medieval and Renaissance illuminated manuscripts, incunabula, early printed books and bindings, and literary and historical manuscripts. Its design was inspired by the Italian Renaissance villa, notably the Villa Pia in the Vatican, constructed between 1558 and 1562. Morgan's elegant one-story pavilion was built of Tennessee limestone, and its stone blocks were set as mortarless marble walls in the tradition of the Erechtheum on the Acropolis. The Library was the masterwork of architect Charles Follen McKim (1847–1909) and was completed in 1906. Morgan and his wife lived in a neighboring brownstone at 219 East 36th Street, and the financier accessed his private library by crossing the

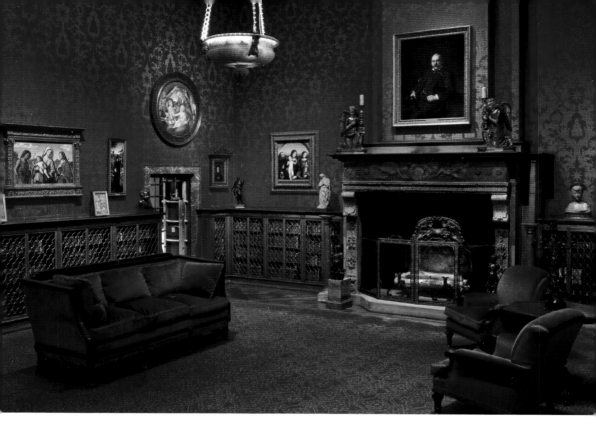

The West Room of the
Morgan Library

lawn, where its monumental bronze doors would be opened for him.
In March 1924, just over a decade after Morgan's death, his son John
Pierpont Morgan Jr., known as Jack Morgan (1867–1943), transformed the
private library into a public institution, initially for the use of scholars and
researchers. The Pierpont Morgan Library was incorporated as a public
institution in March 1924, retaining at its head Morgan's private librarian,
Belle da Costa Greene (1879–1950), who would serve as the institution's
first director until her retirement in 1948. Following the death of Morgan's
widow Frances ("Fanny") Tracy in October 1924, their brownstone on 36th
and Madison was replaced by a two-story neo-Italianate Annex designed
by Benjamin Wistar Morris and completed in 1928. The Annex's discreet
entrance, located at 29 East 36th Street, served to welcome visitors to the
Morgan until 2006.

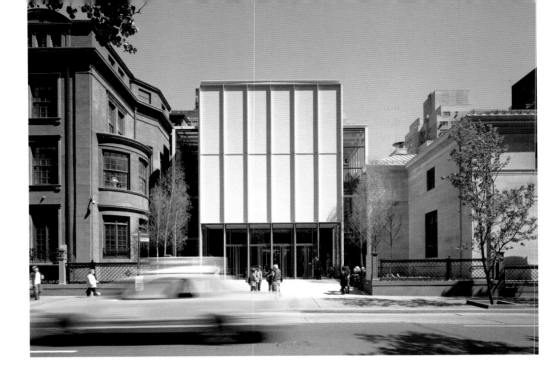

The present-day entrance to the Morgan Library & Museum

In 1988 the Library bought Jack Morgan's previous residence at 231 Madison Avenue (on 37th Street), which after his death in 1943 had been acquired as the headquarters of the United Lutheran Church in America. This brownstone was incorporated into the Morgan complex: as an example, the institution's bookstore now occupies the former ballroom on the ground floor. In 1991 the Annex was also redeveloped and a glass conservatory was designed by Bartholomew Voorsanger to connect the two structures. (Voorsanger's addition would be removed a decade later.) In 2002 the Morgan opened the 5,600-square-foot Thaw Conservation Center, built on the fourth floor of the historic Morgan house, which supports paper and book conservation.

A far more radical and ambitious building expansion, which added 75,000 square feet to the campus, was initiated by the Trustees in 2001, when Italian architect Renzo Piano was invited to build a four-story steel-and-glass entrance building. Piano's design, completed in 2006, placed

the public entrance squarely on Madison Avenue. To signal a commitment to greater accessibility and public engagement, the institution was renamed the Morgan Library & Museum. Piano's master plan integrated McKim's Library building, the Annex, and the Morgan house in a campus that centered on the soaring, light-filled Gilbert Court, which the architect has referred to as a "piazza." Four new galleries for exhibitions and displays were created, and visitors now entered the interiors of the historic Library through a set of stairs at the Gilbert Court's southeast corner. The historic Library's four principal rooms—the West Room (Morgan's study), the East Room, the North Room (the librarian's office), and the Rotunda—were restored and relit in 2011, and they present rotations from the permanent collection. Piano also designed the Gilder Lehrman Hall, an auditorium for lectures and concerts with over 260 seats, located some 65 feet below street level; the Sherman Fairchild Reading Room on the third floor above the Gilbert Court; the Horace Goldsmith Education Center; and a suite of new underground vaults for collection storage, created by drilling into Manhattan's bedrock schist to a depth of 55 feet. In 2019 the Morgan Library & Museum implemented a four-year restoration of the historic Library's facade and added a new garden surrounding McKim's building, designed by landscape architect Todd Longstaffe-Gowan and completed in 2022.

In 1909 Belle da Costa Greene had expressed her ambitions for the Library to "the Big Chief," as she and others occasionally called Morgan. The institution should be "pre-eminent, especially for incunabula, manuscripts, bindings and the classics." In addition to the collecting areas to which Morgan and his son were committed, over the century since its founding the Morgan Library has expanded its remit to include music manuscripts, modern and contemporary works on paper, and photography. A small sampling of treasures from each of the eight collecting departments is included in this book, arranged chronologically by department.

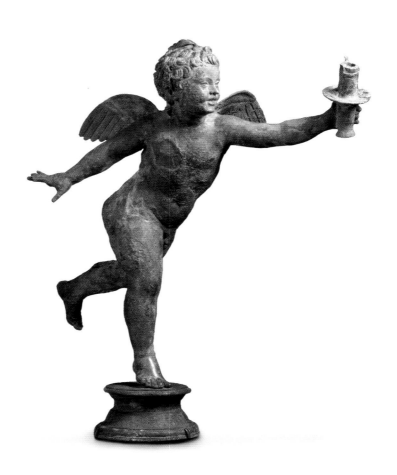

Running Eros, Holding a Torch
Hellenistic Greece, 2nd or 1st century BC

Bronze; 20¼ in. (51.4 cm)
Purchased by J. Pierpont Morgan, 1902; AZ010

LIKELY DATING TO THE SECOND OR FIRST CENTURY BC, this Hellenistic bronze was apparently Morgan's favorite object; his son-in-law recalled that he wanted to have it "constantly in sight." The running putto—a naked child with tiny wings—is portrayed holding the base of a torch into which a candle would have been inserted. A symbol of Eros, god of Love, the figure parts his lips as if he is slightly out of breath, and the beginning of a smile appears on his face. The bronze figure was among a trove of precious objects excavated in 1895 in Boscoreale, near Naples, a town on the slope of Vesuvius, just above Pompeii. This was the site of several Roman villas that had been destroyed in the eruption of the volcano in AD 79. The surviving objects remained buried underground for almost two thousand years until their excavation. This helps explain the corrosion visible over much of the figure's body. Despite the surface damages, the naturalism and grace of this sculpture—as well as the expressive modeling of the putto's face—remain unimpaired. Such characteristics exemplify the achievement of classical Greek art, which continued to be prized by ancient Roman aristocrats, who collected such objects for use and display in their luxurious country retreats.

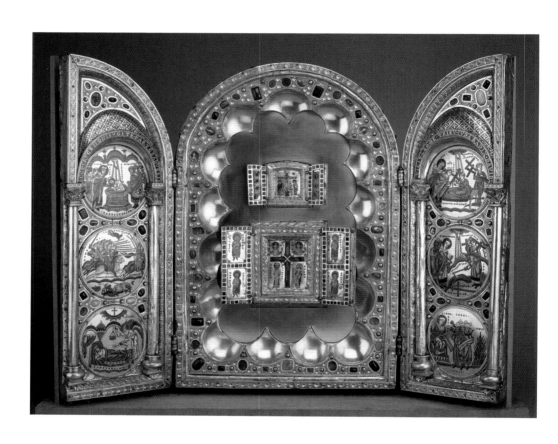

Stavelot Triptych

Setting and medallions: Belgium, ca. 1156–58; Byzantine enamels:
Constantinople, ca. 1100

Champlevé enamel on gilded copper, silver, vernis brun, and precious stones, with plaques and medallions in
cloisonné enamel on gold; 19 × 26 in. (48.4 × 66 cm)
Purchased by J. Pierpont Morgan, 1910; AZ001

THIS GLORIOUS, JEWEL-STUDDED TRIPTYCH—a work of art in three sections—
was likely commissioned in the 1150s by Wibald, abbot of the Benedictine
monastery of Stavelot (in present-day Belgium), as a reliquary to hold
fragments of the True Cross, as well as relics from the Church of the Holy
Sepulchre and remnants from the Virgin's dress. In the reliquary's central
section are mounted two small Byzantine triptychs, dating from the late
eleventh or early twelfth century, which Wibald probably acquired on one
of his diplomatic missions to Constantinople. The most sacred of Christian
relics is encased in the center of the lower triptych, decorated with two
gold pins and four tiny pearls. Its two wings are adorned with figures of
four Byzantine military saints, considered holy warriors. These flank the
Archangels Gabriel and Michael in glory above Emperor Constantine (ca.
273–337) and his mother, Helena (ca. 250–329), portrayed standing at either
side of the Cross. The smaller triptych above shows Christ on the Cross
attended by the Virgin Mary at left and Saint John the Evangelist at right.

The larger wings are decorated with six roundels, made by artists
from the Meuse region in the ancient diocese of Liège, relating epi-
sodes in the life of Constantine and Helena. They are among the finest
and best preserved twelfth-century enamels produced in a technique
known as champlevé, in which the vitreous enamel is contained in cavi-
ties hollowed out of a thick copper plate. Reading from bottom left, we
see the sleeping Emperor Constantine, to whom an angel appears in a
dream telling him to go into battle under the sign of the True Cross ("By
This, Conquer"). Above, Constantine and his army are shown defeating
Emperor Maxentius in battle at the Milvian Bridge in AD 312. At upper left
Constantine is baptized by Pope Silvester. The roundels on the right-hand
panel are devoted to Helena's discovery of the True Cross in Jerusalem.
Again, starting at the bottom, we see her interrogating by fire a group of
Jews who inform her that a certain Judas knows the location of the Cross.

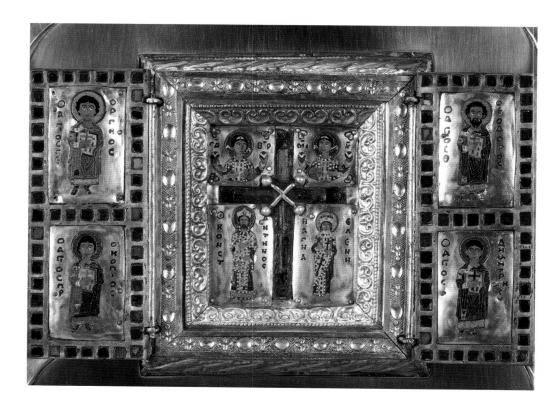

Above: Detail of center panel

Opposite: Detail of left panel

In the roundel above, the aforementioned Judas is shown excavating the three crosses at Golgotha. At upper right, a bishop (Makarios?)—shown next to Saint Helena, crowned by a double tiara—identifies the True Cross when it miraculously restores the seated young man to life.

The Abbot of Stavelot served as an adviser and agent for three successive Holy Roman Emperors and was a fervent supporter of the Second Crusade. Evoking the majesty of the Heavenly Jerusalem, the Stavelot Triptych also championed the cause of maintaining Christian control of the earthly city itself.

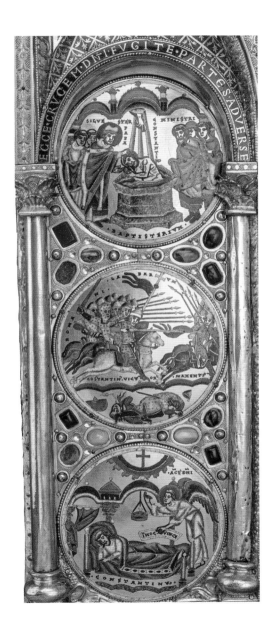

Antonio Rossellino (Italian, 1427–1479)

Virgin and Child with Cherubim, 1450–55

Marble; 31½ × 22⅛ in. (80 × 56.2 cm)

Purchased by J. Pierpont Morgan, 1913; AZ069

Seated on a heavenly throne, with three lively angels behind her—two at left, one at right—the Virgin holds the Christ Child in a gentle, protective embrace. Shown in a three-quarter pose, she supports the infant underneath his shoulder with her right hand, steadying him as he sits on her lap. The Christ Child places his right foot on his mother's left wrist, and rests his toes on her embroidered cuff. Mother and son look in different directions, with the Christ Child casting his gaze on the viewer directly below. A masterpiece of Florentine Renaissance devotional sculpture, this marble was likely made for a domestic setting, although we do not know who commissioned it. (The frame was added in the nineteenth century.) Antonio Rossellino carved *Virgin and Child with Cherubim* partly in low relief, in a technique known as *rilievo schiacciato* (literally, "flattened relief"), with finely engraved, chiseled lines in the background. The heads of the Virgin and Child are fully modeled and emerge from the delicately rendered details. As was customary with this sort of relief sculpture, the most fully worked areas of the composition, such as the arm of the throne and the Virgin's left hand, are to be found in the lower section, which would have been closest to the viewer looking up at the wall-mounted object. Rossellino had encountered Donatello's innovative naturalism in the 1450s and absorbed the older sculptor's example of imbuing the carving of marble with pictorial effects. Note, for example, the Virgin's braided coiffure, the diaphanous veil that falls from her hair, and the folds of her garment, into which the fingers of her left hand disappear.

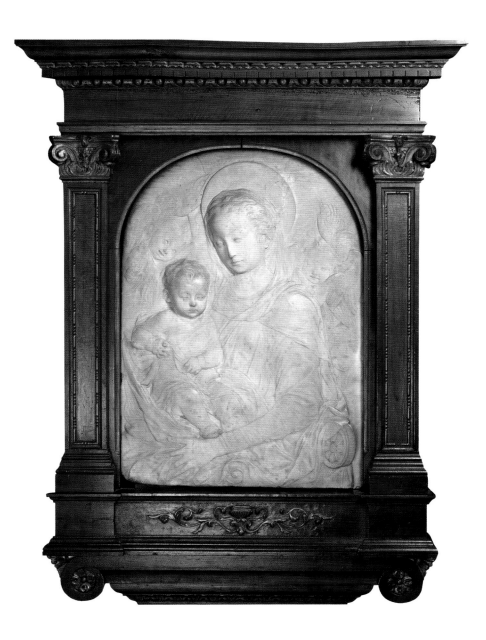

Hans Memling (Netherlandish, 1430/1440–1494)

Portrait of a Man with a Pink, ca. 1480–85

Oil on panel; 10¾ × 15 in. (27.3 × 38.1 cm)

Purchased by J. Pierpont Morgan, 1907; AZ073

This elegant portrait of a young man holding a carnation (or pink)—a symbol of love—between the finely painted fingers of his left hand was likely one of a pair of paintings commissioned to commemorate his betrothal of marriage. (The portrait of his bride has not been identified.) The unknown sitter, with his medium-length hair, fur-lined lapel, and visible collar, is also shown with a piece of folded paper in his right hand on which Gothic lettering can be seen. This might be a love letter or, more prosaically, a marriage contract. By the 1470s Hans Memling had established himself as the leading religious painter and portraitist in the city of Bruges, operating a prestigious workshop and attracting an international clientele of sitters. In this meticulously observed and sympathetically rendered portrait, the solemn young man is shown wearing a black velvet cap; his chestnut hair is cut straight across his forehead; there is stubble on his chin, and he has a pronounced Adam's apple. Originally, his face and neck would have stood out against a bright blue-green background, which has darkened over time. Memling also heightens the realism of his portrayal by placing the sitter's fingers at the edge of the panel, creating the illusion that they are projecting into the viewer's space. Memling's sitter was likely a member of the merchant class and might have been part of the Italian community working in Bruges, which provided Memling with an impressive cohort of foreign patrons.

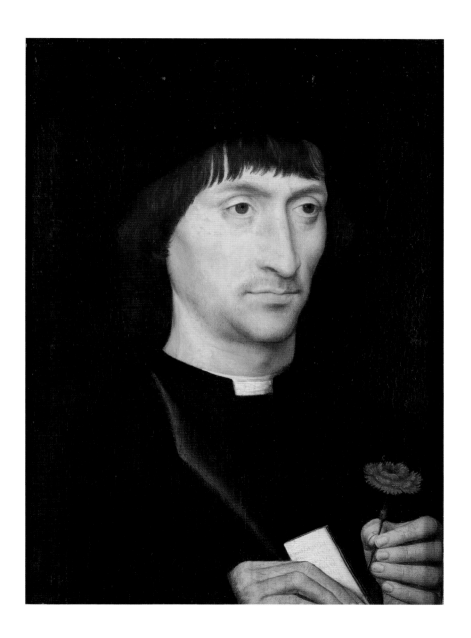

Foundation Figure of King Ur-Namma
Mesopotamia, Ur III period, Reign of Ur-Namma, ca. 2112–2095 BC

Copper alloy; 13 3/16 × 5 1/8 in. (33.5 × 13 cm)
Purchased by J. Pierpont Morgan before 1908; MLC 2628

AROUND ONE FOOT IN HEIGHT, this exquisitely modeled figure was cast in copper and likely placed beneath the foundations of a temple in Nippur, a sacred city in southern Mesopotamia (today, southeastern Iraq). The inscription on the man's skirt tells us that the figurine represents "Ur-Namma, King of Ur, King of Sumer and Akkad, who rebuilt the temple of Enlil." Ur-Namma, the first ruler of the Third Dynasty of Ur, reigned between 2112 and 2095 BC. Enlil, the god associated with wind, air, earth, and storms, was venerated as the supreme Mesopotamian deity. Assuming the attire of a priest, the king is shown with his head shaved and his torso bare, holding a basket that contains the mud to make the temple's bricks. He is represented "carrying the basket"—a lowly occupation in Mesopotamian society—for in the presence of the gods, even the king is a humble servant. (For comfort, however, the basket is supported by a cushion.) The freestanding copper sculpture was made by craftsmen in royal service to commemorate Ur-Namma's rebuilding campaign. It was not meant to be gazed upon by human eyes but was buried in the temple's foundation for the delectation of the deity to whom the building was consecrated.

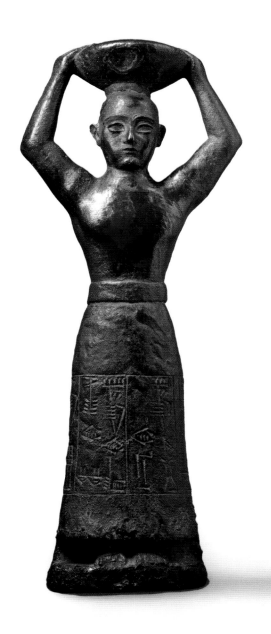

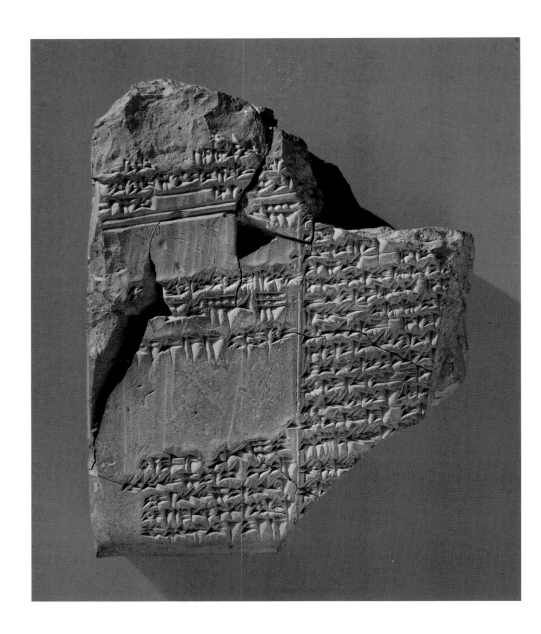

Tablet Inscribed in Akkadian with a Fragment of the Babylonian Flood Story from the Epic of Atrahasis
Mesopotamia, First Dynasty of Babylon, Reign of King Ammi-saduqa, ca. 1646–1626 BC

Clay; 4½ × 3⁹⁄₁₆ in. (11.4 × 9 cm)
Purchased by J. Pierpont Morgan between 1898 and 1908; MLC 1889

THIS ANCIENT CLAY TABLET is in cuneiform script, the oldest form of writing, which originated in Mesopotamia around 3200 BC. Texts were written by pressing a cut, straight reed into moist clay; the characteristic wedge-shaped strokes give the writing its modern name (cuneiform means simply "wedge-shaped"). This tablet was made around 1646–1626 BC in the Babylonian city of Sippar, on the east bank of the Euphrates. We know this thanks to the colophon—a brief statement containing information about the scribe, the text, and the title, "When gods were men"—that is preserved in this fragment. Here we have the earliest known version of the Deluge story, a source for the Epic of Gilgamesh and the story of Noah's Flood recounted in Genesis. This tablet, written in Akkadian, is part of the Epic of Atrahasis and contains the creation myths of the Sumerian gods of sky, wind, and water. Enki, god of water, warns the hero Atrahasis that the cruel god Enlil is planning to destroy humankind by casting a devastating flood over the land and urges him to build a boat in order to escape.

The wild animals . . . of open country, / Two by two he brought on board the boat. / The flood roared like a bull, / Like a wild ass screaming the winds / . . . For seven days and seven nights / The torrent, storm and flood came on.

Winged Hero Contesting with a Lion for a Bull
Mesopotamia, Neo-Babylonian, ca. 800–650 BC

Carnelian with partly preserved copper setting; 1½ × ¹¹⁄₁₆ in. (3.9 × 1.8 cm)
Purchased by J. Pierpont Morgan between 1885 and 1908; Morgan Seal 747

BETWEEN 1885 AND 1908 the American clergyman and editor William Hayes Ward assembled a collection of 1,157 cylinder seals for Morgan's library. These tiny objects, just over one inch in height, were carved with simple tools on semiprecious stones. The seals served to identify their owners and could be worn as amulets to bring good luck. Each cylinder seal is engraved with scenes that appear in relief when the seal is rolled over clay. This vibrant example of Neo-Babylonian art of the seventh century BC is carved on car- nelian, a brownish-red mineral that is used as a semiprecious gemstone. We are witnessing a heroic struggle between the superhuman hero at left and a ferocious lion, who are fight- ing over the bull. The victorious winged hero, with his sickle-sword behind him, places his left foot firmly on the bull's head, holding one of the animal's hind legs in his left hand. His lion opponent raises its sharp claws in a demonic gesture. Despite the violence of the combat, the war- ring figures are stately, as if arrested in time. A constant theme in Mesopotamian art and religion, battle dramas such as this one symbolized the struggle for world order against the forces of chaos. Here the conflict has been transposed from the natural world to the realm of the supernatural, symbolizing the enduring vigilance with which civilization must protect itself.

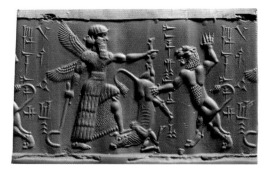

Modern impression from the seal

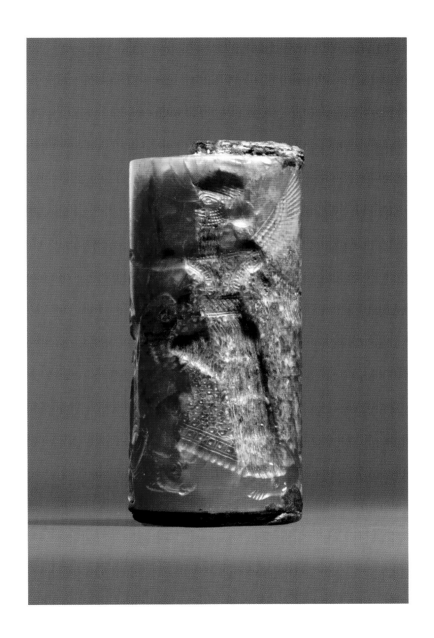

Lindau Gospels

Front cover: Court School of Charles the Bald,
Eastern France, ca. 870
Gold repoussé, gold filigree, and decorated with jewels, attached to wooden board; 13 ¼ × 10 ¹³/₁₆ in.
(35 × 27.5 cm)

Back cover: Salzburg region, Austria, late 8th century
Gilt silver, enamel, gems, and cut glass, attached to wooden board; 13¾ x 10¹³/₁₆ in. (35 x 27.5 cm)
Purchased by J. Pierpont Morgan, 1901; MS M.1

ON A COVER OF EMERALDS, sapphires, pearls, garnets, and amethysts, the figure of the crucified Christ is framed on a gold, bejeweled cross. His arms are outstretched and blood drips from his wounds. The Latin inscription identifies Christ as the King of the Jews ("Hic est Rex iudeorum"). Directly above that inscription are the moon and the sun, in mourning. In the upper two gold quadrants, with raised clusters of jewels (or bosses) at their center, are four angels who look down upon the crucified Son of God. In the quadrants below are the grieving Virgin Mary and Saint John the Evangelist, and at the lowest register, two elongated female figures in anguish. These relief figures were created in a technique known as repoussé: they were modeled by tiny hammers and punches from the reverse of the gold plaque so that the forms themselves bear no sign of the metalworker's tools.

The front cover of the Lindau Gospel, with its 327 precious gems, was likely made around 870 in the court workshop of Emperor Charles the Bald, ruler of the Western Frankish Kingdom (an area that today is in eastern France). The back cover (see p. 26), made of silver gilt, enamel, precious gems, and cut glass, dates from a century earlier, to around 780–800. Likely created in the region near Salzburg, it was made as the cover for a different Gospel Book, now lost, that was slightly smaller than the book it came to adorn. The principal motif is a large enamel and silver-gilt cross with flared arms. Surrounding the topaz at the center are the sacred names: Iesus Christus Dominus Noster (Jesus Christ Our Lord). At each arm of the cross is a half-length representation of Christ framed by a red arch of garnets. The four plaques that fill the spaces between the

Front cover

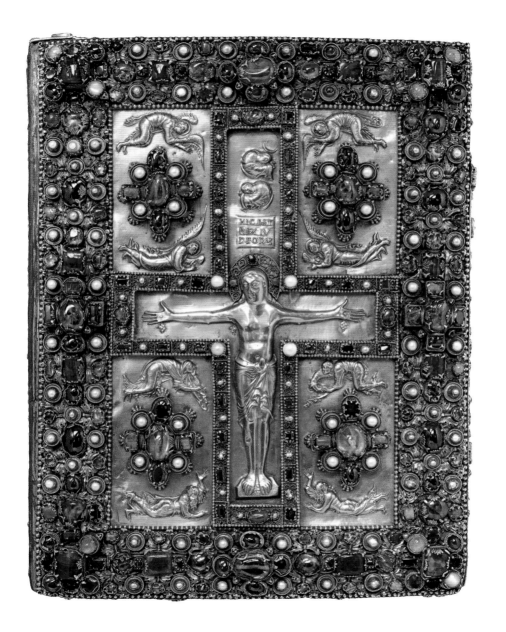

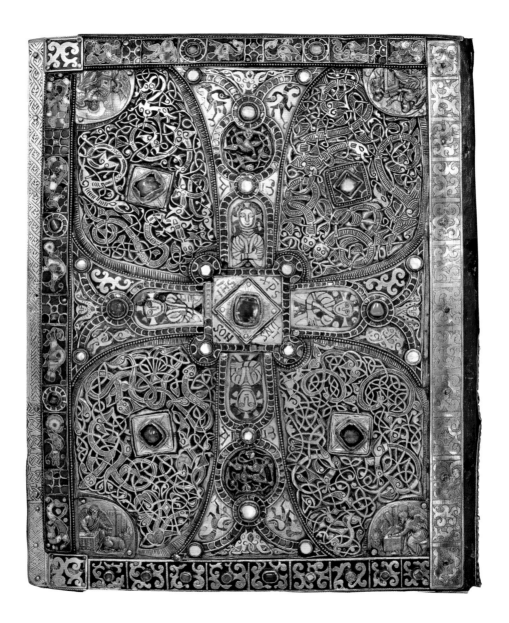

arms of the cross contain a mass of swirling snakes and other creatures, alluding perhaps to the unholiness of the world.

Toward the end of the ninth century, these two covers—made at different times and in different places—found their way, as royal gifts perhaps, to the monastery of Saint Gall, today Saint Gallen, in eastern Switzerland. This wealthy abbey, which served as a center of the visual arts and manuscript production, was under the protection of Charlemagne's grandson, Louis the German, King of East Francia. It seems most likely that, with these two covers in hand, around 880 or 890, a Gospel Book of 224 vellum leaves was commissioned. Lining the inside covers are exquisite Byzantine and Islamic silks from Constantinople.

The Lindau Gospels is thus named because by the end of the sixteenth century it had become part of the holdings of the Abbey and Chapter of the Noble Canonesses at Lindau, on the eastern side of Lake Constance (some 30 miles from Saint Gallen). When this abbey was dissolved in 1803, the Gospels remained in the possession of its abbess; it was sold in 1846 to an aristocratic English collector, and it was from his heir that Morgan, on the advice of his nephew, Junius, acquired it in 1901.

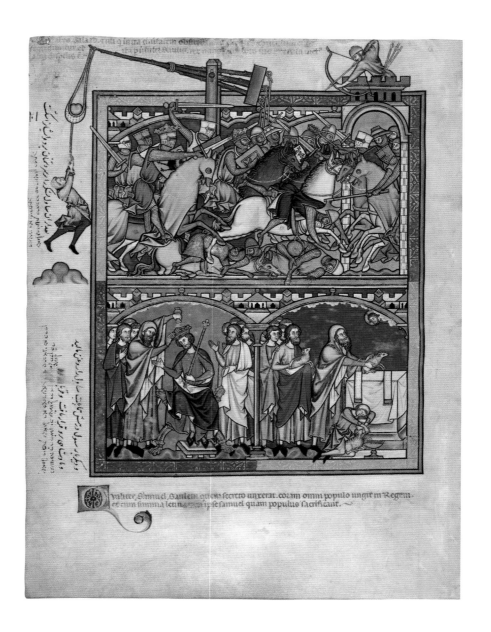

Crusader Bible
Paris, France, ca. 1244–54

Miniature with Latin, Persian, and Judeo-Persian inscriptions on vellum; 15³/₈ × 11¹³/₁₆ in. (39 × 30 cm)
Purchased by J. P. Morgan Jr., 1916; MS M.638

ONE OF THE GREATEST French Gothic picture books to have survived, the Morgan's Crusader Bible consists of forty-three parchment leaves illuminated on both sides with episodes from the Old Testament—many of striking verisimilitude and bloodthirstiness. While it is not known who commissioned the book, it was likely produced under the auspices of the court of Louis IX (1214–1270), the crusading king known as St. Louis who built Paris's Sainte-Chapelle. Seven different artists may have worked on the illuminations in the Crusader Bible, none of whose names is known.

The upper part of the leaf illustrated at left shows King Saul on his steed at left, crowned and dressed in an orange tunic, leading the Israelite army to victory against the Ammonites. With his sword he cleaves the head of the enemy King Nahash, whose army is being slaughtered by the Israelites. Although the illumination depicts episodes from the Old Testament Book of Kings, the protagonists of this epic battle are shown as thirteenth-century Crusaders, with meticulous attention paid to their armor, horses, and weapons. Note the archer atop the battlements at upper right, taking aim at the (as yet) unwounded Ammonite soldier. In the left margin, a soldier is shown about to release an enormous catapult, which will send a boulder into the enemy camp.

The two scenes below represent the prophet Samuel anointing King Saul, who is seated on a throne identical to the royal folding Coronation Chair housed in the Abbey of Saint-Denis. On the right, Samuel and his men offer sacrifices of rams to the Lord, who gazes down benevolently upon them.

Three sets of inscriptions were added to the leaves of the Crusader Bible. The painted initial and Latin description at the lower

MEDIEVAL AND RENAISSANCE MANUSCRIPTS | **29**

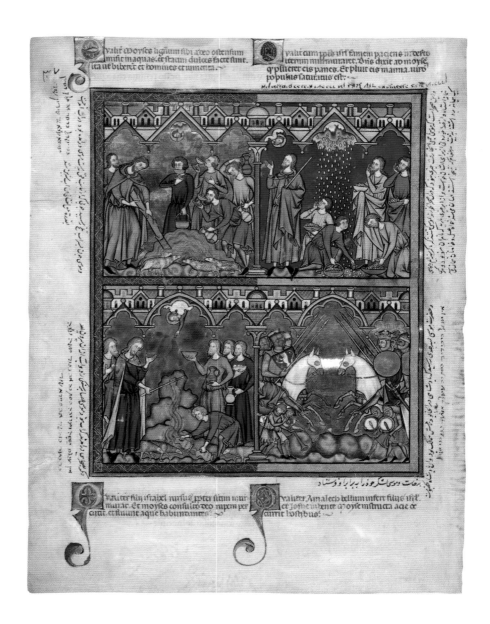

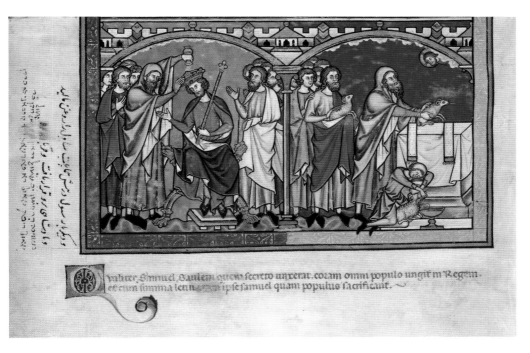

edge were made by an Italian scribe in the early fourteenth century (see detail above). The Persian captions, in large script along the left-hand border, were added after 1608 when the manuscript was presented as a diplomatic gift to the Persian ruler Shah Abbas. The third set of inscriptions, in Judeo-Persian in a smaller hand at the left edge, were made last, in the eighteenth century.

We see even more extensive inscriptions in these three languages on another leaf, illustrated at left, which shows various episodes from the Book of Exodus. In the upper register Moses casts a tree into the bitter waters; next to this, manna rains down from heaven to feed the Israelites. In the lower register, Moses strikes the rock to quench his people's thirst, and in the fourth vignette, Joshua and Amalek lead their troops into battle.

MASTER OF CATHERINE OF CLEVES (Netherlandish, active 1430–60)

Hours of Catherine of Cleves, Utrecht, The Netherlands, ca. 1440

Miniatures with Latin text on vellum; 7⁹⁄₁₆ × 5⅛ in. (19.2 × 13 cm)

Purchased on the Belle da Costa Greene Fund and through the generosity of the Fellows, 1963 and 1970;

MS M.917/945, fols. 1v–2r

THIS LAVISH ILLUMINATED PRAYER BOOK, made in Utrecht around 1440, is the masterpiece of the illuminator known as the Master of Catherine of Cleves. It contains 157 miniatures, many with extremely fanciful borders, of which no two are alike. Books of Hours for lay patrons offered a cycle of prayers, based on the Psalms, that were said at certain hours of the day. The prayers introduced by these miniatures are part of the Hours of the Virgin and would have been recited at Matins, late at night or upon waking.

On the left-hand leaf is shown the patron of the volume, Catherine of Cleves, duchess of Guelders, clad in an ermine-lined red gown, kneeling and praying from the Book of Hours she holds in her hands. She asks the Virgin Mary to intercede with the Christ Child, and the scroll before her reads, "O Mater Dei Memento Mei" (Mother of God, remember me). The miniature to the right refers to the Virgin's birth: an angel informs her father, Joachim, that his wife, Anna, is with child. The rabbits frolicking behind him attest to the family's new-found fecundity.

Of particular interest are the heraldic devices in the borders of both illuminations, all of which refer to Catherine's noble ancestry. The escutcheon at center in the border below the Virgin shows her coat of arms, as duchess of Guelders, surmounted by a red-faced ox, the crest of Catherine's father, Adolph, duke of Cleves. Entirely excised from the illumination is any reference to Catherine's husband, Duke Arnold of Egmont, from whom she was estranged at the time of commissioning this book, and with whom she would be engaged in a protracted political battle for the rest of her life.

MASTER OF CLAUDE DE FRANCE (French, active ca. 1498–1520)

Prayer Book of Queen Claude de France, Tours, France, ca. 1517

Miniatures with Latin text on vellum; 2¾ × 2 in. (6.9 × 4.9 cm)

Gift of Mrs. Alexandre P. Rosenberg in memory of her husband Alexandre Paul Rosenberg, 2008; MS M.1166, fols. 24v–25r

THIS TINY PRAYER BOOK with 132 pictures is less than three inches tall and two inches wide. It was probably commissioned around 1517 by the eighteen-year-old Queen Claude of France to commemorate her coronation. Claude had married François d'Angoulême in 1514, one year before he ascended to the French throne as King François I. The couple had seven children over the next ten years.

The artist responsible for these delicate illuminations and borders, known as the Master of Claude de France, trained and worked in Tours and was active in the first and second decades of the sixteenth century. The pairing illustrated here, which includes the only full-page miniature in the book, shows the Trinity, with groups of adoring angels at right. In the left-hand leaf, God the Father is seated at right and places his left hand on a book with a lavish blue cover that rests upon his knee. He is giving instruction and benediction to his son, the pre-Incarnate Christ, who solemnly places his left hand on the book. The Dove of the Holy Spirit hovers above them; at their feet we see a globe of the world, as yet unredeemed by Christ's sacrifice.

Around the borders of the Trinity is a girdle with loosely tied knots in a figure-eight design. This is the device of the House of Savoy, from which François d'Angoulême descended, and so makes reference to Claude's husband, the only time he is so instanced in this book. Just as God the Father provided a son for the world's salvation, so was François I expected to father the next king of France. By contrast, the border of the right-hand leaf—a rope with tightly tied knots, which appears on nearly every page of the book—is the girdle of the knotted cord, or *cordelière*, that was the symbol of a Franciscan order founded by Claude's mother, Queen Anne de Bretagne. It was the personal device of both mother and daughter.

GIULIO CLOVIO (Croatian, 1498–1578)

Farnese Hours, Rome, Italy, 1546

Miniatures with Latin text on vellum; 6¹³/₁₆ × 4⁵/₁₆ in. (17.3 × 11 cm)
Purchased by J. Pierpont Morgan, 1903; MS M.69, fols. 38v–39r

GIULIO CLOVIO's sumptuously and abundantly illustrated Book of Hours was commissioned by twenty-six-year-old Cardinal Alessandro Farnese (1520–1589), who had assumed his office aged fourteen, and whose grandfather Pope Paul III had been a patron of Michelangelo. (Indeed, in his own day Clovio was called "a new Michelangelo in miniature.") The manuscript consists of twenty-six painted miniatures and numerous historiated borders and may have taken as long as nine years to complete, which would suggest that it was started around 1537. In this pairing we see the *Adoration of the Magi* at left and *Solomon Visited by Queen Sheba* on the right, from which a small man at lower left looks out defiantly at the reader. The extravagant illusionistic frames, festooned with masks, fruit, and drapery, show nude male figures, inspired by Michelangelo's Sistine Chapel ceiling, with naked putti frolicking along the lower and upper registers. The twisting columns in King Solomon's palace were inspired by the baldachin in the basilica of the Old St. Peter's in Rome. The Latin inscriptions beneath the paintings—"Deus, in adiutorium meum intende" (O God come to my assistance) and "Domine, ad adiuvandum me festina" (O Lord make haste to help me)—from the Seventieth Psalm, introduced the prayers recited in midafternoon at the canonical hour of Nones within the Hours of the Virgin. In his second edition of the *Lives of the Most Excellent Painters, Sculptors, and Architects,* published in 1568, the painter and art historian Giorgio Vasari, who knew Clovio, wrote that the Farnese Hours "is one of the greatest things that mortal hand could do or mortal eye could behold."

Gutenberg Bible *(Biblia Latina)*

Mainz: Johann Gutenberg and Johann Fust, ca. 1454–55

Printed on vellum; 16¾ × 13 in. (42.5 × 33 cm)
Purchased by J. Pierpont Morgan, 1896; PML 13/818, fols. 131v–132r

IN THE MID-1450S, a goldsmith and inventor from Mainz, Johann Gensfleisch zum Gutenberg, produced the first Latin Bible printed from movable type, in columns of forty-two lines. Gutenberg's invention of printing was based on the casting of metal type in reverse and assembling a page of text letter by letter and line by line. Each page would be inked and printed, by means of a press, onto leaves of paper or parchment. The types could be disassembled, cleaned, and used again for the setting of additional pages. Gutenberg, his business partner Johann Fust, and Gutenberg's apprentice Peter Schöffer, produced some 180 Bibles, of which forty-eight mostly intact volumes survive today. The Morgan owns three copies, one on vellum and two on paper.

These large folio volumes containing the Latin Vulgate text of the Old and New Testaments marked a milestone in the development of typographic printing. But before the volumes could be considered complete, the printed gatherings—with their black, shiny, relatively easy-to-read Gothic script—had to be decorated by hand. The typographers left spaces for the headings, running titles, and initials that were painted by illuminators, who might also embellish the pages with intricate borders. The Morgan's vellum copy was likely ornamented by more than one artist at different times. The elaborate initials were done by a German illuminator, while the elegant border decorations, in a different hand, are thought to have been provided by an artist working in Bruges.

Gutenberg Bibles served a practical purpose as well, since in their lectern format and with their clear typography they were well-suited to being read aloud. In chapter houses and refectories throughout Europe, members of certain religious orders would assemble at meals to follow a rigorous program of Bible reading, as would the

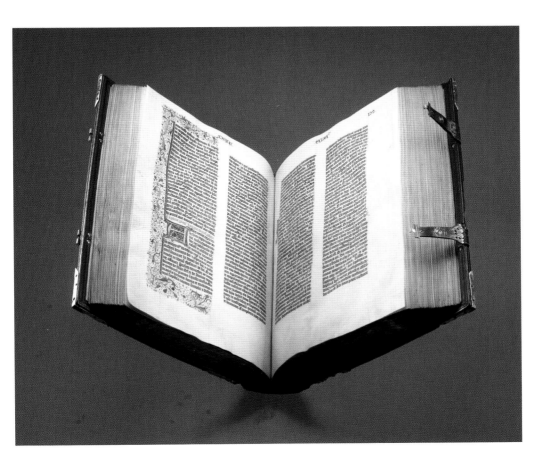

prosperous and devout laity in the privacy of their homes. Despite the considerable investment required in their ambitious start-up, Gutenberg and Fust had identified a new market, and their innovation ushered in one of the greatest revolutions in the history of Western civilization: the dissemination of knowledge through printing.

Sir Thomas Malory (English, ca. 1416–1471)

Thus endeth thys noble and joyous book entytled le morte Darthur
Westminster: [William Caxton], 1485

11¼ × 8³⁄₁₆ in. (28.6 × 20.8 cm)
Purchased by J. Pierpont Morgan, 1911; PML 17560, leaf ee6r

The cloth merchant, printer, and translator William Caxton (1422–1491) introduced the printing press to England in 1476, when he set up offices in Westminster, London, and produced the first edition of Geoffrey Chaucer's *Canterbury Tales*. (He had gained experience printing books in Cologne, Ghent, and Bruges.) Over the next quarter of a century, Caxton was responsible for publishing more than one hundred books on religion, history, and chivalric romances, including many translations. His edition of Sir Thomas Malory's *Le Morte Darthur* was published on July 31, 1485, as noted in the colophon of the book: "Thus endeth thys noble and joyous book entytled le morte Darthur, Notwythstanding it treateth of the byrth, lyf and actes of the sayd kyng Arthur."

The Morgan holds the only complete copy of this chivalric romance; the manuscript from which the book was printed is in the British Library. It recounts the legend of King Arthur and Queen Guinevere, the Knights of the Round Table and their quest for the mystical Holy Grail. The author, Malory, was a criminal figure from the landed gentry in Warwickshire who seems to have completed this medieval romance in Newgate prison, London, in 1469, where he described himself as a "knight prisoner." Malory's primary source had been a late fourteenth-century French poem. Along with Chaucer's works, Malory's book, written in the English vernacular at a time when French and Latin remained the official languages, became a model for shaping the English language as a literary form.

Perhaps Pierre-Paul Dubuisson (French, active 1746–62), binder

Heures nouvelles dédiées à Madame Royale . . .
Brussels: Jean Joseph Boucherie, 1759

Binding: Dark red morocco, with gilt dentelle and vase-of-flowers motif;
5⅛ × 3½ in. (13 × 9 cm)
Bequest of Julia P. Wightman, 1995; PML 125711

IN FRANCE DURING THE ANCIEN RÉGIME, the practice of placing elaborate gold-tooled decorative bindings on printed books in royal and aristocratic libraries reached new heights of craftsmanship and luxury. This small prayer book, printed in Brussels in 1759, first belonged to Queen Maria Leszczyńska, the devout wife of King Louis XV. The book was dedicated to her, and she distributed many such religious works as pious gifts, referring to them as "my little missionaries." In this instance she turned to the royal bookbinder Pierre-Paul Dubuisson to produce the decorative Morocco leather binding, which shows a vase of flowers in the center, with butterflies and other insects circling around it. These devices were made by impressing gold leaf onto the leather with stamps and hand tools of different sizes. The lacelike borders, known as a dentelle, that decorate all four sides of the cover are symmetrical in their design; a fillet, or set of double straight lines around the outer edge of the book, completes the ornamentation.

Queen Maria Leszczyńska likely bequeathed this book to her granddaughter, Élisabeth de France, known as Madame Élisabeth. The unmarried Madame Élisabeth took the prayer book with her when she and her family—which included her brother King Louis XVI and his wife, Queen Marie Antoinette—were imprisoned in the Temple fortress by the Republican government in August 1792. On the flyleaf, she inscribed her name and the site of her captivity —"Elizabeth/Tempel [*sic*] 1793"—and added a drawing of the three crosses of the Crucifixion. Madame Élisabeth would be guillotined on the Place de la Révolution—today the Place de la Concorde—on May 10, 1794.

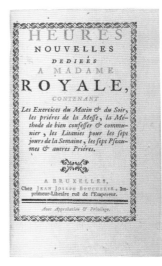

Title page

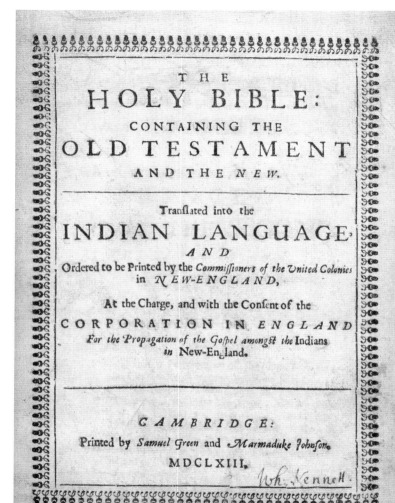

THE
HOLY BIBLE:
CONTAINING THE
OLD TESTAMENT
AND THE *NEW.*

Translated into the
INDIAN LANGUAGE·
AND
Ordered to be Printed by the *Commissioners of the United Colonies*
in *NEW-ENGLAND,*

At the Charge, and with the Consent of the
CORPORATION IN *ENGLAND*
For the Propagation of the Gospel amongst the Indians
in New-England.

CAMBRIDGE:
Printed by *Samuel Green* and *Marmaduke Johnson.*
MDCLXIII.

John Eliot (English, 1604–1690), trans.

The Holy Bible (Algonquian Bible)
Cambridge [MA]: Printed by Samuel Green and Marmaduke Johnson, 1663
11⅜ × 7⅞ in. (29 × 20 cm)
Purchased with the Irwin Collection, 1900; PML 5441

The first Bible printed in America was a translation of the New Testament in the Natick dialect of the Algonquian language released in 1661 in an edition of 1,500 copies. In 1663 followed a two-volume edition of both the Old and New Testaments, with a print run of 1,180. This endeavor was led by the Puritan divine, "the Revd. Translator" John Eliot, who had immigrated to New England in 1631 and became a minister in Roxbury the following year. Eliot studied the Massachusett language, preached his first sermon in it in 1646, and received funding from the Society for Promoting and Propagating the Gospel of Jesus Christ in New England for this ambitious project, which was intended to assist in the conversion of Native Americans to Christianity.

Eliot's translation took more than a decade to complete, and he was helped by two Native American converts, John Sassamon, who had studied at Harvard's Indian College, and Job Nesutan. (Sassamon also served as a scribe and interpreter.) The first printing press had arrived in the colonies from England in 1638; paper and an assistant printer for Eliot's Algonquian Bible were sent from London in 1660; another convert, James Wowaus, assisted in the presswork.

In their efforts to introduce Christianity to the Massachusetts colony, Eliot and his fellow Puritan missionaries also established some fourteen "Praying towns," which led to the conversion of over 3,600 Native Americans. Such activities were abruptly brought to an end in 1675–76 by the violent and bloody conflict, known as King Philip's War, between the New England tribes led by Metacomet, a Wampanoag sachem (chief), and the English colonists. In addition to the enormous loss of life, most of the Algonquian Bibles were destroyed during the fighting.

William Blake (English, 1757–1827)

America: A Prophecy
Lambeth [London]: Printed by William Blake, 1793
(this copy printed 1795)

12⅝ × 9⁷⁄₁₆ in. (32 × 24 cm)

Purchased by J. Pierpont Morgan, 1909; PML 16134, pl. 3

During his lifetime Blake was employed as a printer and engraver, with his own printshop in North Lambeth, London. Alongside his commercial practice, he was also an innovative poet, printmaker, and painter, and it is as a pioneer of Romanticism that he is recognized today. As a private publisher and printmaker of original works in small editions, Blake mastered and expanded the techniques of relief etching and illuminated printing. He was skilled at reverse or mirror writing in both cursive and roman. Using pens and brushes with an acid-resistant medium, he inscribed his poems onto the copper plate and expertly integrated the text within his visionary illustrations.

The first of Blake's series of Prophetic Books, *America: A Prophecy*, printed in 1793, was a poem inspired by the American Revolution, in which historical figures such as George Washington and Thomas Paine appear alongside mythological characters of Blake's invention. In the two-page Preludium, the fiery Orc, "lover of wild rebellion" and the personification of cosmic energy, is shown chained to the top of a hill, visited by "the shadowy daughter of Urthona." The first printing of *America* comprised eighteen plates, printed on both sides of the sheet in complex variations of greenish-black and bluish-black inks. In 1795 Blake printed two more copies—both held today at the Morgan Library & Museum. The copy shown here was hand-colored by Blake and acquired by George Romney, the fashionable English portrait painter; it is one of only five colored copies known.

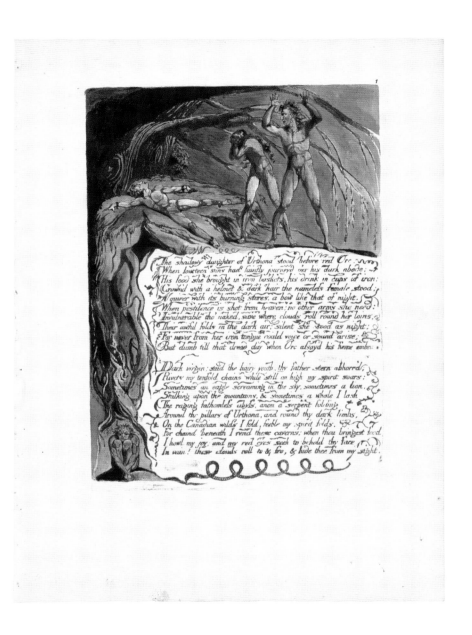

The shadowy daughter of Urthona stood before red Orc.
When fourteen suns had faintly journey'd oer his dark abode;
His food she brought in iron baskets, his drink in cups of iron:
Crownd with a helmet & dark hair the nameless female stood;
A quiver with its burning stores, a bow like that of night,
When pestilence is shot from heaven; no other arms she need:
Invulnerable tho' naked, save where clouds roll round her loins,
Their awful folds in the dark air; silent she stood as night;
For never from her iron tongue could voice or sound arise;
But dumb till that dread day when Orc assay'd his fierce embrace.

Dark virgin; said the hairy youth, thy father stern abhorr'd;
Rivets my tenfold chains while still on high my spirit soars;
Sometimes an eagle screaming in the sky, sometimes a lion,
Stalking upon the mountains, & sometimes a whale I lash
The raging fathomless abyss, anon a serpent folding
Around the pillars of Urthona, and round thy dark limbs,
On the Canadian wilds I fold, feeble my spirit folds.
For chaind beneath I rend these caverns; when thou bringest food
I howl my joy, and my red eyes seek to behold thy face
In vain! these clouds roll to & fro, & hide thee from my sight.

En ce temps-là j'étais en mon adolescence
J'avais à peine seize ans et je ne me souvenais déjà plus de mon enfance
J'étais à 16 000 lieues du lieu de ma naissance
J'étais à Moscou, dans la ville de mille et trois clochers et des sept gares
Et je n'avais pas assez des sept gares et des mille et trois tours
Car mon adolescence était alors si ardente et si folle
Que mon cœur, tour à tour, brûlait comme le temple d'Éphèse ou comme la Place Rouge de Moscou
 Quand le soleil se couche.
 Et mes yeux éclairaient des voies anciennes
 Et j'étais déjà si mauvais poète
 Que je ne savais pas aller jusqu'au bout.

Le Kremlin était comme un immense gâteau tartare
Croustillé d'or,
Avec les grandes amandes des cathédrales toutes blanches
Et l'or mielleux des cloches...
Un vieux moine me lisait la légende de Novgorode
J'avais soif
Et je déchiffrais des caractères cunéiformes
 Puis, tout à coup, les pigeons du Saint-Esprit s'envolaient sur la place
 Et mes mains s'envolaient aussi, avec des bruissements d'albatros
 Et ceci, c'était les dernières réminiscences du dernier jour
 Du tout dernier voyage
 Et de la mer.

Pourtant, j'étais fort mauvais poète
Je ne savais pas aller jusqu'au bout.
J'avais faim
Et tous les jours et toutes les femmes dans les cafés et tous les verres
J'aurais voulu les boire et les casser
Et toutes les vitrines et toutes les rues
Et toutes les maisons et toutes les vies
Et toutes les roues des fiacres qui tournaient en tourbillons sur les mauvais pavés
J'aurais voulu les plonger dans une fournaise de glaives
Et j'aurais voulu broyer tous les os
Et arracher toutes les langues
Et liquéfier tous ces grands corps étranges et nus sous les vêtements qui m'affolent...
Je pressentais la venue du grand Christ rouge de la révolution russe...
Et le soleil était une vilaine plaie
Qui s'ouvrait comme un brasier.

En ce temps-là j'étais en mon adolescence
J'avais à peine seize ans et je ne me souvenais déjà plus de ma naissance
J'étais à Moscou, où je voulais me nourrir de flammes
Et je n'avais pas assez des tours et des gares que constellaient mes yeux
En Sibérie tonnait le canon, c'était la guerre
La faim le froid la peste le choléra
Et les eaux limoneuses de l'Amour charriaient des millions de charognes

Dans toutes les gares je voyais partir tous les derniers trains
Personne ne pouvait plus partir car on ne délivrait plus de billets
Et les soldats qui s'en allaient auraient bien voulu rester...
À vous suivre sheitel la légende de forgeron.
 Moi, le mauvais poète qui ne voulait aller nulle part, je pouvais aller partout
 Et aussi les marchands avaient encore assez d'argent
 Pour aller tenter faire fortune.
 Leur train partait tous les vendredis matin.
 On disait qu'il y avait beaucoup de morts.
 L'un emportait cent caisses de réveils et de coucous de la Forêt-Noire
 Un autre, des boîtes à chapeaux des cylindres et un assortiment de tire-bouchons de Sheffield
 Un autre, des cercueils de Malmö remplis de boîtes de conserve et de sardines à l'huile.
 Puis il y avait beaucoup de femmes
 Des femmes des entre-jambes à louer qui pouvaient aussi servir
 Des cercueils
 Elles étaient toutes patentées
 On disait qu'il y avait beaucoup de morts là-bas
 Elles voyageaient à prix réduits
 Et avaient toutes un compte-courant à la banque.
 OR, UN VENDREDI MATIN CE FUT AUSSI MON TOUR
 ON ÉTAIT EN DÉCEMBRE
 ET JE PARTIS MOI AUSSI POUR ACCOMPAGNER LE VOYAGEUR EN BIJOUTERIE QUI SE RENDAIT À KHARBINE
 NOUS AVIONS DEUX COUPÉS DANS L'EXPRESS ET 34 COFFRES DE JOAILLERIE DE PFORZHEIM
 DE LA CAMELOTTE ALLEMANDE « MADE IN GERMANY »

IL M'AVAIT HABILLÉ DE NEUF ET EN MONTANT DANS LE TRAIN J'AVAIS PERDU UN BOUTON
— JE M'EN SOUVIENS, JE M'EN SOUVIENS, J'Y AI SOUVENT PENSÉ DEPUIS —
JE COUCHAIS SUR LES COFFRES ET J'ÉTAIS TOUT HEUREUX DE POUVOIR JOUER AVEC LE BROWNING NICKELÉ
QU'IL M'AVAIT AUSSI DONNÉ

J'étais très heureux insouciant
Je croyais jouer aux brigands
Nous avions volé le trésor de Golconde
Et nous allions grâce au transsibérien le cacher de l'autre côté du monde
Je devais le défendre contre les voleurs de l'Oural qui avaient attaqué les saltimbanques de Jules Verne
 Contre les khoungouzes les boxers de la Chine
 Et les enragés petits Mongols du Grand-Lama
 Alibaba et les quarante voleurs
 Et les fidèles du terrible Vieux de la montagne
 Et surtout, contre les plus modernes
 Les rats d'hôtel
 Et les spécialistes des express internationaux.

Et pourtant, et pourtant
J'étais triste comme un enfant
Les rythmes du train
La « moelle chemin-de-fer » des psychiatres américains
Le bruit des portes des voix des essieux grinçant sur les rails congelés
Le ferlin d'or de mon avenir
Mon browning le piano et les jurons des joueurs de cartes dans le compartiment d'à côté

Blaise Cendrars (Swiss, 1887–1961)
Sonia Delaunay-Terk (Ukrainian, 1885–1979)

La Prose du Transsibérien et de la petite Jehanne de France
Paris: Éditions des hommes nouveaux, 1913

78⅜ × 14 in. (199.1 × 35.5 cm)
Gift of Dr. Gail Levin, 2021; PML 198726

Arguably the most beautiful artist's book produced in the twentieth century, *La Prose du Transsibérien et de la petite Jehanne de France* was a collaboration in Paris in 1913 between the Ukrainian-born abstract painter Sonia Delaunay-Terk and the Swiss-born poet Frédéric Louis Sauser, who changed his name to Blaise Cendrars—with its associations of burning to create poetry through the ashes of life. Cendrars's poem, illustrated by Delaunay's colorful designs, was printed on four large sheets of paper pasted together and folded into pleats resembling the bellows of an accordion. Self-published, their accordion book contains 446 lines of poetry set in letterpress, employing thirty different typefaces in four colors. The left sides of the already-printed pages were then decorated by hand by female printshop workers who applied gouache with a brush through dozens of different stencils, in a technique known as pochoir. Delaunay's maquette, which was scrupulously followed, called for a series of concentric circles, rainbow effects, and layers of color. The Eiffel Tower and a Ferris wheel appear at the bottom of the page. On the right side of the printed page, a new scheme of overlapping colors was painted around the type, with strict instructions from the artist not to cover any of the text. With her husband, Robert, Delaunay was a pioneer of Simultanism in abstract painting, drawing upon earlier theories of color contrast to create optical effects that expressed rhythm, movement, and energy.

The long tale of the author's imaginary travels on the Trans-Siberian Railway from Moscow to China in the company of a young woman from Paris is a tour de force of free verse. "Say, Blaise, are we really that far from Montmartre?" is a refrain that recurs throughout their journey. Cendrars is said to have described his work as "a sad poem printed on sunlight."

Sɪʀ Iꜱᴀᴀᴄ Nᴇᴡᴛᴏɴ (English, 1643–1727)

Memorandum book, 1659

Autograph manuscript; 5 × 2⅝ in. (12.6 × 6.6 cm)
Purchased by J. Pierpont Morgan, 1907; MA 318, fols. 10v–11r

Tʜɪꜱ ʜᴜᴍʙʟᴇ ᴠᴇʟʟᴜᴍ-ʙᴏᴜɴᴅ memorandum book, still in its original binding—acquired by the seventeen-year-old Newton for two and a half pennies—is one of four surviving notebooks from the scientist's late adolescence, when he was a scholar at the King's School, Grantham, Lincolnshire, and an undergraduate at Trinity College, Cambridge. Newton's discoveries of differential calculus and the universal theory of gravitation were a long way in the future when the young student set about taking notes from the books he was reading. He copied sections on drawing and painting from the second edition of John Bate's *The Mysteries of Nature and Art*, published in 1635. In addition to noting medical recipes, Newton included a section on "Extravigants," or miscellaneous experiments, and a list of "Certaine tricks"—the page illustrated here—which show how "to turne waters into wine" as well as into several other types of alcoholic beverage.

After starting his studies at Cambridge University in June 1661, Newton began to compile information relating to scientific mathematical principles, such as the solar and lunar cycles and an astronomical calendar. He took notes on Copernicus's heliocentric theory of the solar system, experiments regarding perpetual motion, mathematical solutions for triangles, and "questions in Navigation."

At a certain point Newton had turned his book over and started writing from the other side, compiling extensive word lists based on Francis Gregory's school textbook *Nomenclatura brevis anglo-Latinis* (1634) under categories such as beasts, diseases, husbandry, and "man, his affections & senses."

Recipes for ye eye-sight.

X Things hurtfull for ye Eyes.

Garlick Onions & Leeks. over much
Lettise. Going too suddaine after meate
Hot wines. Cold ayre. Dunknes. Glut-
tony. Milke. Cheese. White & red coul-
lers. Much sleepe after Meate. Much
bloodletting. Cold herbs dust. fire
much weeping. & watching.

Things good for ye sight.
Measurable sleepe. red roses. fen-
oll. Solandine. Vervaine rootes
X Pimpernell. Oculus Christi. &
wash ye Eyes in faire running
water, & yor hands & feet often.
To looke on any greene or pleasant
colours, or in a faire glasse.

A Water to cleare ye sight
Take greene Wallnuts huskes & all as
X they come from ye trees & a few of
ye leaves & distill them. Then drop
ye water therof into yor fyinoourning
& night for 6 or 7 days together.

Drop 3 or 4 drops of ye water of
rotten apples at a time into ye eyes

Wash yor eyes with ye water of
Daises. both roots & leaves being
X cleane washed, then stamped &
strained.
The juice of ye herbe
Euphrasia, or ye water.

X Another.

Take a new laid egg, roast it hard, cut
ye shell in ye midst or take out ye yolke
cleane & put a wine of Coppras in roome
ye yolke lay, binding ye egg together again
let it so ye fire till ye Coppra
was too dissolved to water, yn take all
ye white out of ye shell cutting it in
small peices, yn put it into a glass of
faire running water letting it stand
for a little while, yn straine it throng
a fine lining cloth, & keepe it in a glass
close stoped to wash yor eyes every
morning & evening herewith.

Certaine tricks.

To turne waters into
wine
1 Into Clarret.
X
Take as much lockwood as you
can hold in yor mouth wthout
discovery tye it up in a cloth, & put
it in yor mouth, then sup up some
water & champe ye lockwood 3 or
4 times & doe it out into a glass.
2 for White wine.
Chew ye Ball once or twice lightly, or as
you did for clarret.

JANE AUSTEN (English, 1775–1817)

Lady Susan, ca. 1794–95

Autograph manuscript, fair copy; 7½ × 6⅛ in. (19.1 × 15.6 cm)
Purchased in 1947; MA 1226, p. 1

THIS MANUSCRIPT FAIR COPY of 158 pages is the only surviving complete draft of any of Austen's novels. Free of almost any corrections or alterations, it was made after 1805, the date of the watermark found on two of the sheets of paper. Austen was probably transcribing her original draft for the printer, which was likely destroyed, although the novel was not published during her lifetime. Austen's sister, Cassandra, gave the manuscript to their favorite niece, Fanny Catherine Knight, later Lady Knatchbull. *Lady Susan* was first printed in 1871 as an appendix to Austen's nephew's *Memoirs of Jane Austen*; it was first published as an independent work by Clarendon Press in 1925 and reissued by Penguin in 2014.

Austen had not yet turned twenty when she embarked upon *Lady Susan*, an early work dating to around 1794–95. It is written as an epistolary novel, a literary form that enjoyed a heyday in the second half of the eighteenth century, with the plot developed over a series of forty-one letters. The heroine of Austen's novel is the glamorous Lady Susan Vernon, an inveterate flirt and "the most accomplished coquette in England," who is a widow in her thirties with an unmarried sixteen-year-old daughter, Frederica. Having enjoyed an affair with the married Mr. Manwaring, Lady Susan descends upon the country estate of her brother-in-law and his wife, Charles and Catherine Vernon, and schemes to find a wealthy suitor for her daughter while also toying with the affections of her hostess's younger brother, Reginald De Courcy. Reginald will gradually win the affections of Frederica, with whom he is more suited in age and temperament. Lady Susan eventually accepts the hand of the wealthy and besotted landowner Sir James Martin—whom she had initially intended for her daughter—while remaining determined to continue her amorous relations with the dashing Manwaring.

Jane Austen. Engraving after a drawing by Cassandra Austen; image: 4¾ × 3¾ in. (12 × 9.6 cm). London: Richard Bentley, 1870. The Morgan Library & Museum; MA 1034.12.

Letter 1.

Lady Susan Vernon to M.ʳ Vernon.

Langford, Dec.ᵇ —

My dear Brother

I can no longer refuse myself the
pleasure of profitting by your kind invitation when
we last parted, of spending some weeks with you.
at Churchill, & therefore if quite convenient to
you & M.ʳˢ Vernon to receive me at present, I
shall hope within a few days to be introduced
to a Sister, whom I have so long desired to be ac:
quainted with. — My kind friends here are most
affectionately urgent with me to prolong my stay,
but their hospitable & chearful dispositions lead them

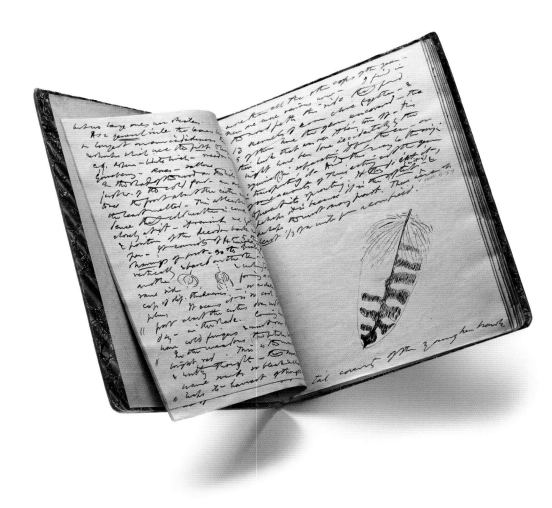

Henry David Thoreau (American, 1817–1862)

Journal, November 9, 1858–April 7, 1859

Autograph manuscript; 9¹³/₁₆ × 7⁷/₁₆ in. (24.9 × 18.9 cm)

Purchased by J. Pierpont Morgan with the Wakeman Collection, 1909; MA 1302.34, pp. 112–13

After graduating from Harvard College in 1837, naturalist, essayist, poet, and philosopher Henry David Thoreau was employed in his family's pencil-making business in Concord, Massachusetts, and also had stints as a school teacher and land surveyor. Encouraged by his mentor Ralph Waldo Emerson, Thoreau espoused the precepts of Transcendentalism, a movement that developed in New England with core beliefs in the goodness of the individual and the benevolence of nature, and preached the virtues of self-reliance and independence. Shortly after graduation, Thoreau began to keep the journal that would grow to some two million words in forty-seven volumes, thirty-nine of which are housed at the Morgan Library & Museum, along with the stout pine box that he built to preserve the notebooks.

These handwritten journals provide a lifetime of Thoreau's careful, eloquent observations of the natural world, season after season, for almost a quarter of a century. (He began keeping a journal on October 22, 1837; the last entry is dated November 3, 1861, six months before his death.) While they provide the source material for the two books (and many articles) that Thoreau published during his lifetime—notably *A Week on the Concord and Merrimack Rivers* (1849) and *Walden: or, Life in the Woods* (1854)—the journals constitute a significant literary achievement in their own right and are also replete with illustrations of plants, leaves, flowers, and fungi (and even a pressed spider). The entry for November 11, 1858, illustrated here, shows the feather of a hawk that one of Thoreau's neighbors had killed after the bird had been caught attacking his chickens. Thoreau had taken the bird home to examine it more closely. He may also have felt a certain kinship with the species, since he noted in a subsequent journal entry, "The same thing that keeps the hawk in the woods—away from the city—keeps me here."

VINCENT VAN GOGH (Dutch, 1853–1890)

Letter to Paul Gauguin, Oct. 17, 1888, with a sketch of
The Bedroom

Pen and brown/black ink on one vertically folded sheet of white wove, blue squared paper;
10⅜ × 8¼ in. (26.4 × 21 cm)
Thaw Collection, given in honor of Charles E. Pierce Jr., 2007; MA 6447

AN INVETERATE LETTER WRITER, Van Gogh is thought to have sent
no fewer than two thousand letters to his family and friends, chief
among whom was his brother, Theo van Gogh. Of those letters, 820
survive today, containing some 240 sketches. The Morgan Library
& Museum owns twenty letters, with fourteen sketches, all but one
of which were sent to the artist's younger colleague Émile Bernard.

The letter illustrated here was written on October 17, 1888, to Paul
Gauguin, who was about to make the journey by train from Pont-
Aven in Brittany to join Vincent in his "yellow house" on the Place
Lamartine in Arles, where the two artists would share a home and
studio for two months. As he often did, Vincent included a draw-
ing of the canvas on which he was currently working, a painting of
his bedroom on the upper floor. He notes that he is working with a
"simplicity worthy of Seurat"—a reference to the neo-Impressionist
Georges Seurat—"in flat tints, but coarsely brushed in full impasto."
In his affectionate depiction of this bare but tidy bedroom, with its
whitewood furniture, neat bedding, straw-covered chairs, washbasin,
and paintings and drawings over the bed, Vincent told Gauguin, "I had
wished to express *utter repose* with all these very different tones."

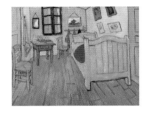

Vincent van Gogh, *The Bedroom*,
1888. Oil on canvas; 28½ × 36 in.
(72.4 × 91.3 cm). Van Gogh
Museum, Amsterdam (The
Vincent van Gogh Foundation).

Van Gogh hoped that with Gauguin's arrival, his rented home in
Arles would become a "Studio of the South." Unfortunately, the situation
between the two artists deteriorated and two months later, on December
23, 1888, Gauguin hurriedly made his exit after Vincent, in a fit of mania,
attacked him with a razor, which he then used to mutilate his left ear.
All of this was far in the future when Vincent, full of optimism,
wrote: "I've had gas put in the studio, so that we'll have good light in
winter . . . I believe that once here, like me, you'll be seized with a fury
to paint the autumn effects . . . And that you will understand that I've
insisted that you come now that there are some very beautiful days."

Eh bien cela m'a énormément amusé
de faire cet intérieur. Rien.
D'une simplicité à la Seurat

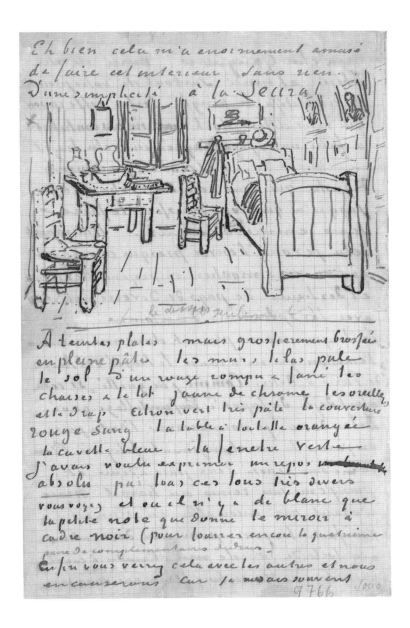

A teintes plates mais grossièrement brossé
en pleine pâte les murs lilas pâle
le sol d'un rouge rompu à fané les
chaises et le lit jaune de chrome les oreillers
et le drap citron vert très pâle la couverture
rouge sang la table à toilette orangée
la cuvette bleue la fenêtre verte
J'avais voulu exprimer un repos
absolu par tous ces tons très divers
vous voyez et où il n'y a de blanc que
la petite note que donne le miroir à
cadre noir (pour fourrer encore la quatrième
paire de complémentaires dedans)
Enfin vous verrez cela avec les autres et nous
en causerons car je ne sais souvent

OSCAR WILDE (Irish, 1854–1900)

The Picture of Dorian Gray, 1890

Autograph manuscript; 12 ¹⁵⁄₁₆ × 8 ⅛ in. (32.9 × 20.6 cm)

Purchased 1913; MA 883, p. 1

WILDE'S 50,000-WORD NOVELLA was commissioned by the Philadelphia-based J. B. Lippincott Company's publication *Lippincott's Monthly Magazine*, in the summer of 1889. It appeared in the July 1890 issue and would be extended to twenty chapters when published as a book the following year. (This would be Wilde's only full-length novel.) *The Picture of Dorian Gray* tells the story of the beautiful young aristocrat Dorian Gray, friend of the painter Basil Hallward, who is led into a life of hedonism and pleasure by the older, married libertine Lord Henry Wotton. Hallward's full-length portrait of Dorian is kept locked in an attic, and as part of a Faustian pact, Dorian—who commits a series of crimes and murders—will remain forever young while his portrait ages. Haunted by his evil, Dorian finally destroys the portrait by slashing it with a knife. In the final scene, the portrait recovers its original pristine beauty and Dorian is found by a servant lying dead on the attic floor, aged, hideous, and disfigured.

The Morgan's manuscript of 262 leaves is a holograph fair copy—a document written in the hand of the author—that was itself copied by Wilde from an earlier draft that is now lost. (There are also numerous revisions and corrections by Wilde in the Morgan's manuscript.) Wilde sent this handwritten copy to Miss Dickens's Typewriting Service in the Strand, London. The typescript, with Wilde's further annotations and revisions—held today at the William Andrews Clark Memorial Library, UCLA (see p. 60)—was the version used by *Lippincott's* to set the work in print.

In its celebration of the cult of beauty, pleasure, and sensual delight, and in its frank discussion of homosexual love and desire, Wilde's novel prompted considerable outcry. Five years earlier, the British Government had passed the Criminal Law Amendment Act of 1885, which established the crime of Gross Indecency for virtually

The Picture of Dorian Gray.

The studio was filled with the rich
odour of roses, and when the light summer
wind stirred amidst the trees of the
garden there came through the open door
the heavy scent of the lilac, or the
more delicate perfume of the pink flowering
thorn.

From the corner of the divan of Persian
saddle-bags on which he was lying, smoking,
as usual, innumerable cigarettes,
Lord Henry Wotton could just catch the
gleam of the honey-sweet and
honey-coloured blossoms of the laburnum, that
were hanging from the tremulous branches that
seemed hardly able to bear the burden of
a beauty so flame-like as theirs: and,
now and then, the fantastic shadows of birds
in flight flitted across the long tussore-silk
curtains that were stretched in front of
the huge window, producing a kind of
momentary Japanese effect, and making
him think of those pallid jade-faced
painters who, in an art that is
necessarily immobile, seek to convey the
sense of swiftness and motion. The
sullen murmur of the bees shouldering
their way through the long unmown grass

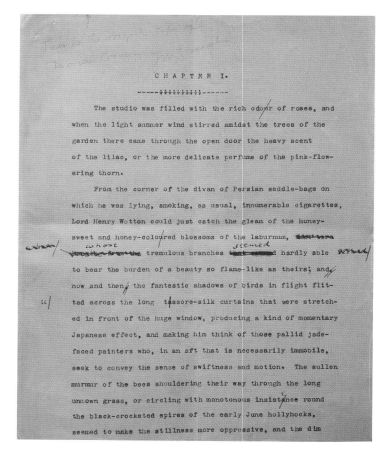

CHAPTER I.

The studio was filled with the rich odour of roses, and when the light summer wind stirred amidst the trees of the garden there came through the open door the heavy scent of the lilac, or the more delicate perfume of the pink-flowering thorn.

From the corner of the divan of Persian saddle-bags on which he was lying, smoking, as usual, innumerable cigarettes, Lord Henry Wotton could just catch the gleam of the honey-sweet and honey-coloured blossoms of the laburnum, *whose* tremulous branches *seemed* hardly able to bear the burden of a beauty so flame-like as theirs; and now and then the fantastic shadows of birds in flight flitted across the long tussore-silk curtains that were stretched in front of the huge window, producing a kind of momentary Japanese effect, and making him think of those pallid jade-faced painters who, in an art that is necessarily immobile, seek to convey the sense of swiftness and motion. The sullen murmur of the bees shouldering their way through the long unmown grass, or circling with monotonous insistence round the black-crocketed spires of the early June hollyhocks, seemed to make the stillness more oppressive, and the dim

Left: Oscar Wilde, *The Picture of Dorian Gray*, annotated typescript, 1890, p. 1. The William Andrews Clark Memorial Library, University of California, Los Angeles.

Opposite: Portrait of Oscar Wilde by Alfred Ellis & Walery, 1892. Photogravure, published 1915.

any male homosexual behavior, punishable by imprisonment, "with or without hard labour." Wilde, who between 1895 and 1897 served two years in jail for gross indecency, later remarked: "Basil Hallward is what I think I am: Lord Henry what the world thinks me: Dorian what I would like to be—in other ages, perhaps."

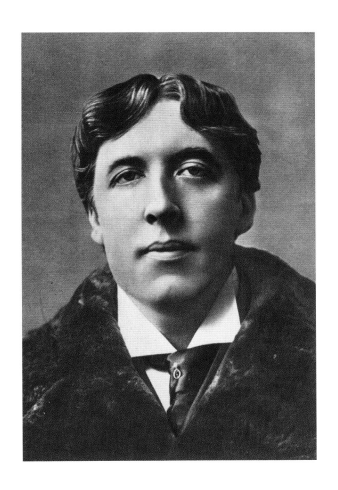

JAMES JOYCE (Irish, 1882–1941)

Ulysses, 1921

Single leaf of manuscript; 10⁷⁄₁₆ × 8¼ in. (26.5 × 21 cm)

Gift of Rowland Burdon-Muller in memory of Belle da Costa Greene, 1950; MA 7148, verso

© The Estate of James Joyce

WRITTEN IN SELF-IMPOSED EXILE between 1914 and 1922 in Trieste, Zurich, and Paris, and set in Dublin over the course of a single day (the 16th of June 1904), Joyce's *Ulysses* follows the young poet Stephen Dedalus and the unlikely hero Leopold Bloom—a cuckolded husband and a figure of rare humanity—as they each wend their way through the city. This groundbreaking modernist novel, with its innovative use of stream of consciousness, linked the epic to the everyday, referencing characters and motifs from Homer's ancient Greek poem *The Odyssey* in a tale of the Irish city and its citizens that created Joyce. Privately printed in France in February 1922 by the American publisher Sylvia Beach, proprietor of the Parisian bookstore Shakespeare and Company, the novel appeared on Joyce's fortieth birthday, at his insistence. It was censored and banned in Great Britain and America and was finally published by Random House, New York, in January 1934, after the United States Court of Appeals for the Second District upheld the trial court's ruling that *Ulysses* was not obscene.

The single leaf shown here forms part of "Ithaca," the seventeenth episode of *Ulysses*, which takes the form of a mock catechism in a series of seriocomic questions and answers. Joyce made handwritten revisions to the typescript, and his changes formed the basis for the subsequent new composition on the other side of the sheet. His handwriting is unusually legible, as he was probably making an effort for the typist. Once the new fair copy was produced, Joyce crossed out his revisions with a flourish in blue crayon. He would continue to make amendments, corrections, and additions at all stages of the novel's production.

Grand Lyric Hall on Burgh Quay and the
Theatre Royal in Hawkins Street, dis-
traction resultant from compassion for
Fay Arthur's non-intellectual, non-political,
non-topical expression of countenance and
concupiscence caused by Fay Arthur's re-
velations of white articles of underclothing
while she (Fay Arthur) was in the
articles, the difficulties of
associated with the views of the new
lord mayor, Daniel Tallon, the new
high sheriff, Thomas Pile and the new
solicitor-general, Dunbar Plunket
Barton.

non-intellectual, non-political,
non-topical.

the selection of appropriate music and
humourous allusions,
from Everybody's Book of Jokes (1000
pages and a laugh in every
one)

the rhymes,
homophonous
and cacophonous,

W on the events of the past, or
fixtures for the actual, years
what had prevented him from completing a
topical song, entitled If Brian Boru could but
come back and see old Dublin now commiss-
ioned by Michael Gunn and to be (sung by)
introduced into the second edition of the
Christmas pantomime and sung by
Fay Arthur, principal boy
Oscillation between events of local and of
imperial interest, the diamond jubilee of
Queen Victoria and the opening of the
new municipal fish market, apprehension
of opposition from extreme circles on the
question of the respective visits of their
Royal Highnesses the duke and duchess of
York (real) and of His Majesty Brian Boru
(imaginary), a conflict between professional
etiquette and professional emulation
concerning the recent erections of the

Alors il s'achète :

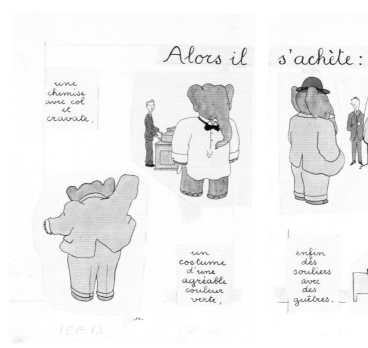

une
chemise
avec col
et
cravate,

un
costume
d'une
agréable
couleur
verte,

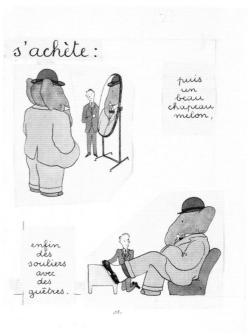

puis
un
beau
chapeau
melon,

enfin
des
souliers
avec
des
guêtres.

Jean de Brunhoff (French, 1899–1937)

Histoire de Babar, 1930–31

Printer's dummy; watercolor and ink on paper; 14⅛ × 10¼ in. (36 × 26 cm)

Gift of Laurent, Mathieu, and Thierry de Brunhoff, and purchased with the assistance of The Florence Gould Foundation and the Acquisitions Fund, Fellows Endowment Fund, Gordon N. Ray Fund, and the Heineman Fund, 2004; MA 6304.10.09 (verso) and 6304.10.10 (recto)

The exploits of Babar—the orphaned baby elephant who fled the forests, came of age in the city, and returned home, married to Celeste, to rule his kingdom—originated in Paris in 1930 as a bedtime story for the two young sons of Jean and Cécile de Brunhoff. An accomplished painter who had never written or illustrated a book, Jean transformed the tale into *Histoire de Babar, le petit éléphant* (*The Story of Babar, the Little Elephant*), which was published in 1931. Six more titles followed before de Brunhoff's untimely death from tuberculosis in 1937. In 1946 the Brunhoffs' eldest son, Laurent, who had heard the stories as a child, wrote and illustrated *Babar et ce coquin d'Arthur* (*Babar's Cousin, That Rascal Arthur*). He would go on to publish forty-five more titles in the series.

The Morgan Library & Museum holds the pencil sketches, drafts, and print-ready watercolors for the first Babar books, acquired in 2004 as a gift from the three sons of Cécile and Jean de Brunhoff. In this double-page illustration that would be printed across the gutter of *Histoire de Babar*, we see Babar on a shopping spree in a fashionable department store. He is able to do this thanks to the generosity of his protector, "the Old Lady who has always been fond of elephants" and who gives him "whatever he wants." The text, in a cursive script similar to the style of handwriting that the boys were being taught at school, reads as follows: "Then he buys himself a suit with a collar and tie, a suit of a becoming shade of green, then a handsome bowler hat, and finally shoes with spats." In his notes on the colors he would use for the final drawings, de Brunhoff had written that Babar should wear a "costume gris"—a gray suit. He changed his mind, replacing "gris" with "vert" (green), and thus was born the distinctive and immediately recognizable apparel of the novel's modest, polite, and endlessly engaging chief protagonist.

Johann Sebastian Bach (German, 1685–1750)

Cantata 112, "Der Herr ist mein getreuer Hirt," BWV 112, 1731

Autograph manuscript; 13⅜ × 8¼ in. (34 × 21 cm)

Mary Flagler Cary Music Collection, 1968; Cary 56, p. 1

This is Bach's twelve-page autograph manuscript score for his Cantata 112, "Der Herr ist mein getreuer Hirt" (The Lord Is My Faithful Shepherd)—the title is inscribed by the composer above the first stave—considered to be of extraordinary beauty and eloquence. He used as his text Wolfgang Meuslin's hymn of ca. 1530–31, which itself was a poetic version of the Twenty-Third Psalm. Bach composed some three hundred church cantatas, two hundred of which survive today, many of them written during his time as cantor of the school at Thomaskirche and director of church music in Leipzig from May 1723. These vocal compositions with instrumental accompaniments, in several movements, often involving a choir, were used in the liturgy of church services.

Cantata 112 has five movements, and opens with a serene choral fantasia, which is based on Nicolaus Decius's hymn "Allein Gott in der Höh sei Ehr" (Alone to God in the Highest Be Glory), composed in 1523. As is indicated in Bach's handwriting at the top of the sheet, the cantata was scored for four voices, two horns, two oboes d'amore, two violins, a viola, and continuo. It was first performed at Leipzig's Nikolaikirche on April 8, 1731, for the Misericordias Domini, celebrated on the second Sunday after Easter. It is thought that the first movement, one of Bach's greatest chorale fantasies, might have been copied from an earlier draft since his penmanship on these pages is so legible and assured. The composer's handwriting becomes increasingly untidy, with many more corrections, as he hurried to complete the score.

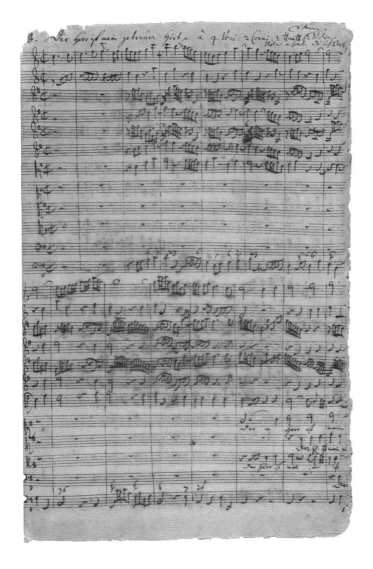

WOLFGANG AMADEUS MOZART (Austrian, 1756–1791)

"Haffner" Symphony No. 35, in D major, K. 385, 1782

Autograph manuscript; 9⁷⁄₁₆ × 12³⁄₁₆ in. (23 × 31 cm)

Mary Flagler Cary Music Collection, 1979; Cary 483, p. 1

Presentation case

MOZART'S BRILLIANT HAFFNER SYMPHONY, which was given its first public performance in Vienna on March 23, 1783, in the presence of Emperor Joseph II, originated in a commission to celebrate the ennoblement of the Salzburg patrician Sigmund Haffner the previous summer. In July 1782 Mozart's father, Leopold, had written to his son in Vienna urgently requesting a new symphony for Haffner's elevation into the nobility. Mozart, whose opera *The Abduction from the Seraglio* had just premiered at Vienna's Burgtheater, was under enormous pressure. As he wrote to Leopold, "I am up to the eyes in work. And now you ask me to write a new symphony! How on earth can I do so?" Over the next month, Mozart sent the different movements of the symphony to his father, section by section, insisting that "the first Allegro must be played with great fire—the last, as fast as possible."

In December 1782 Mozart requested the return of the manuscript from Salzburg for use in the Lenten concert he was preparing, so that he could have copies made for the performance. His father eventually complied and by mid-February 1783 the original score was back in Vienna. As Mozart wrote, "My new Haffner symphony has positively amazed me, for I had forgotten every single note of it. It must surely produce a good effect." For the public concert, he removed the opening march and one of the minuets, and increased the woodwind section.

In August 1865 this fifty-seven-page manuscript was presented as a gift by Karl Mayer Rothschild, Bavarian consul general in Frankfurt, to King Ludwig II of Bavaria to celebrate his twentieth birthday. It was housed in a custom-built case of turquoise velvet and chased silver, which remains at the Morgan.

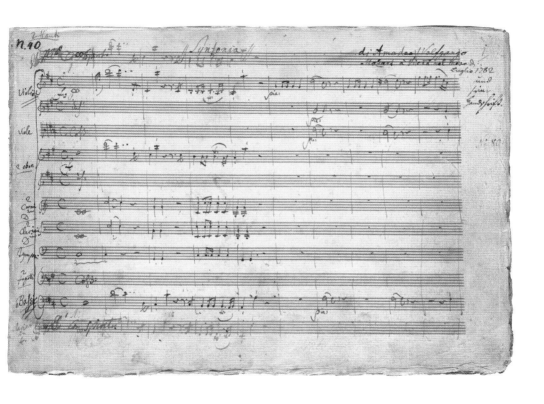

Gustav Mahler (Austrian, 1860–1911)

Symphony No. 5, in C-sharp minor, 1903

Autograph manuscript; 13⅜ × 10⁷⁄₁₆ in. (34 × 26.5 cm)
Mary Flagler Cary Music Collection, 1983; Cary 509, Mvt. 3, "Scherzo," p. 1

Mahler composed his majestic Fifth Symphony during the summers of 1901 and 1902 in his lakeside villa in the Austrian village of Maiernigg on the Wörthersee, and premiered the work to rapturous acclaim in Cologne on October 18, 1904. It introduced a new, purely instrumental orchestral language, with an enriched palette of sound. After the first rehearsal, Mahler wrote to his wife, Alma, "What are they to say to this primeval music, this foaming, roaring, raging sea of sound, to these dancing stars?"

This manuscript score of 297 pages is Mahler's fair copy produced during the winter of 1902–3, which he dedicated in October 1903 to "My dear Almscherl"—his affectionate term for Alma—"the faithful and brave companion on all my journeys." Mahler had married the twenty-three-year-old Alma Schindler in March 1902; the Fifth Symphony's fourth movement, the searing and tender Adagietto written for strings and harp alone, may be understood as a musical love letter to his young bride. Alma also produced a fair copy of the Fifth Symphony, which was to be used as the engraver's text by the Leipzig music publishers C. F. Peters, who had paid generously for the exclusive rights to publish and distribute this new work.

As indicated by the red markings on the first page of the Scherzo illustrated here, Mahler continued to revise and make changes to this symphony. In one of his last letters, written in February 1911, he indulged in a certain amount of hyperbole when he informed a correspondent, "I have finished my Fifth—it had to be almost completely re-orchestrated. I simply cannot understand why I still had to make such mistakes."

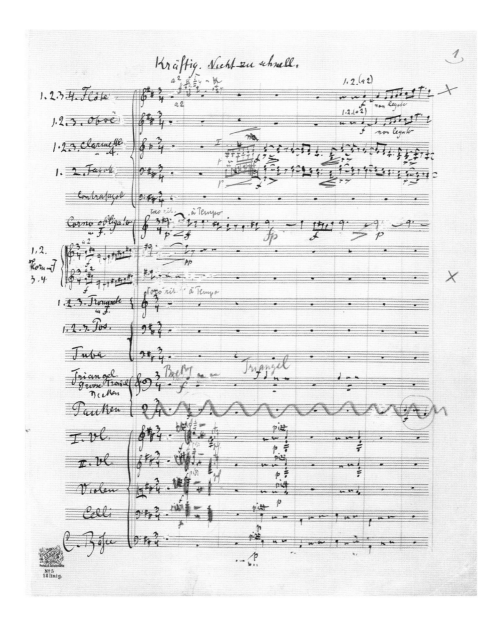

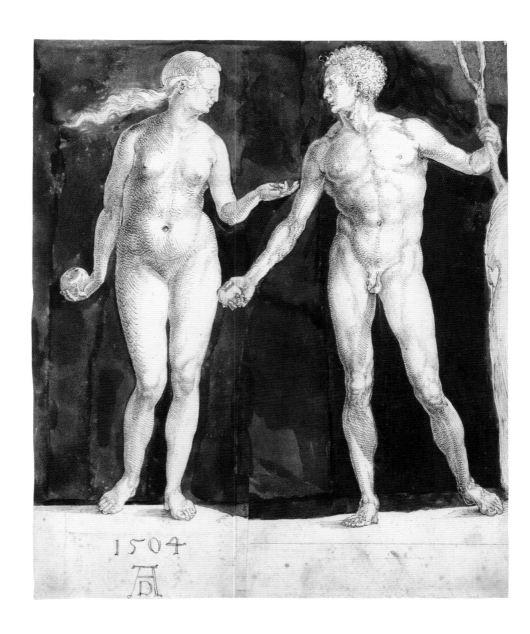

ALBRECHT DÜRER (German, 1471–1528)

Adam and Eve, 1504

Pen and brown ink and wash with white opaque watercolor on three sheets of paper; 9⅝ × 7¹⁵⁄₁₆ in. (24.2 × 20.1 cm)

Purchased by J. Pierpont Morgan, 1910; I, 257d

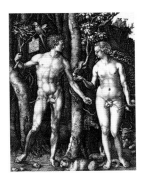

ALBRECHT DÜRER, *Adam and Eve*, 1504. Engraving; sheet: 10⁷⁄₁₆ × 8¼ in. (26.5 × 20.9 cm). The Morgan Library & Museum, purchased as the gift of Eugene V. Thaw, S. Parker Gilbert, Rodney B. Berens, Mrs. Oscar de la Renta, Elaine Rosenberg, T. Kimball Brooker, George L. K. Frelinghuysen, and on the Ryskamp Fund, the Edwin H. Herzog Fund, and the Lois and Walter C. Baker Fund; 2006.8.

DATED 1504 AND SIGNED with Dürer's monogram, this superb composition is the most elaborate of the many drawings made in preparation for the engraving of *Adam and Eve*. Executed in pen and brown ink, with wash applied by the brush and corrections made in white opaque watercolor, the drawing shows Adam and Eve as beautiful, idealized nudes, in keeping with Dürer's systematic investigations of the human body, based on scientific measurements and the study of antiquity. Gazing upon each other at almost eye level, Adam and Eve are each shown with a piece of the forbidden fruit in their right hands. (Their positions are reversed in the print.) Apart from the spindly branch of the Tree of Life that Adam holds with his left hand, Dürer's drawing makes no reference to the various plants, trees, and animals that will fill the landscape in the engraving.

The Morgan's drawing is composed of three sheets of paper, expertly manipulated and joined together by the artist. The figures of Adam and Eve were drawn with great care on two separate pieces of paper, and the drawing was completed by a third strip of paper in the form of a patch. The artist then applied a brown wash as background to cover the joins and unify the composition. In the drawing, Adam and Eve are shown side by side; the figures seem to be of roughly the same height, since the ground upon which Eve stands is slightly elevated. In the engraving, it is Adam who has been raised so that he looks down at Eve, now cast as the more guilty party who is offering her husband the forbidden apple brought by the serpent.

PARMIGIANINO (Italian, 1503–1540)

Christ Child Asleep on the Lap of the Virgin, 1534–40

Red chalk, partially incised with stylus, on paper; 7½ × 5⅝ in. (19.1 × 14.4 cm)

Purchased by J. Pierpont Morgan, 1909; IV, 42

ONE OF MORE THAN FIFTY DRAWINGS made in preparation for the altarpiece known familiarly as the *Madonna of the Long Neck*, Parmigianino's red-chalk sheet is an exquisite and tender depiction of the sleeping Christ Child, nestled in the crook of his mother's left elbow and supported by her left hand. In December 1534 the artist had been commissioned by the noble widow Elena Baiardi Tagliaferri to paint an altarpiece for the funerary chapel of her husband, Francesco, in the church of Santa Maria dei Servi in Parma. Parmigianino was expected to have the painting ready by the spring of 1536, but it remained incomplete at the time of his death four years later. The altarpiece was installed in the chapel in 1542, with an inscription stating that it was unfinished.

Over the course of working out the placement of the altarpiece's various saints and figures in his preparatory drawings, Parmigianino decided to show the Christ Child asleep on his mother's lap, his right leg dangling. Accordingly, the Morgan's drawing focuses all its attention on the sleeping infant. In the final painting the Child is shown in a more horizontal position, with both legs resting on the Virgin's left thigh. The Child's recumbent pose is now reminiscent of a Pietà—a painting or sculpture in which Mary is depicted contemplating the dead body of the crucified Christ whom she holds on her lap or in her arms. Whereas the Christ Child seems bald in the unfinished painting, Parmigianino shows him in this and other preparatory studies with a full head of ringlets.

PARMIGIANINO, *Madonna and Child with Angels (Madonna of the Long Neck)*, 1534–40. Oil on panel; 85 × 52⅛ in. (216.5 × 152.5 cm). The Uffizi, Florence.

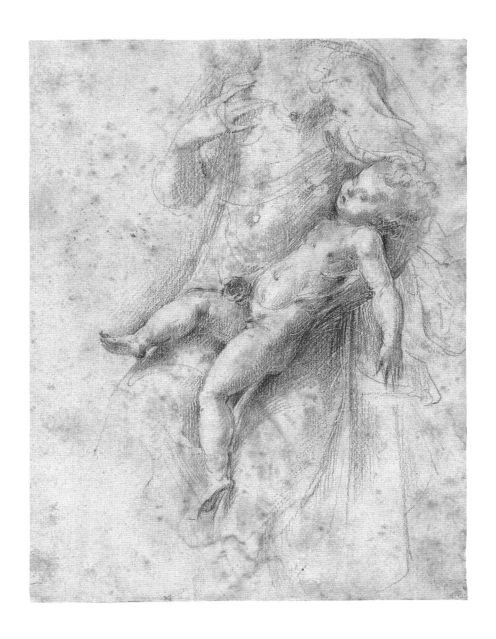

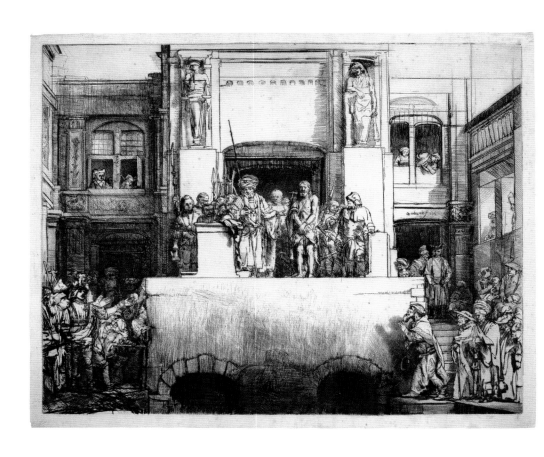

Rembrandt Harmenszoon van Rijn (Dutch, 1606–1669)

Christ Presented to the People: Oblong plate, 1655

Drypoint on paper, 8th state; plate: 14⅛ × 17¹¹⁄₁₆ in. (35.8 × 45 cm)
Purchased by J. Pierpont Morgan, 1905; RvR 119, B.76

Thanks to the two bulk purchases made by J. Pierpont Morgan in 1900 and 1905, the Morgan Library & Museum owns the finest collection of Rembrandt prints in North America, with impressions of most of the three hundred known etchings, often in more than one state. This expansive and dramatic drypoint shows the turbaned Roman Governor Pontius Pilate at center left, holding his rod of judgment as he gestures to the two prisoners standing next to him on the dais. The man with the shaved head and brutal expression is Barabbas, and he is roped to the dignified, sorrowful figure of Christ. Because Pilate could find no fault with Jesus, he asks the assembled populace to decide which of the two men should be set free. As related in the Book of Matthew, the crowd chooses Barabbas.

Rembrandt places the action in the courtyard of Pilate's palace, whose architecture—particularly its flanking statues of Blind Justice and Fortitude—would have reminded contemporary viewers of such recent buildings as Amsterdam's new Town Hall. This mixture of the biblical and the topical recurs in several places, notably in the appearance of Pilate's wife, seated by the window at upper left and conspicuous in her wimple-like headdress. Another example is the flamboyantly attired soldier in the foreground at lower left, who wears a hat with large ostrich plumes.

To create this print, Rembrandt used drypoint, which involved incising the image into the copper plate directly with a hard-point etching needle. The process produces a raised edge, known as a burr, which retains additional ink when the plate is wiped and produces a soft, velvety line. The impression illustrated here is of the eighth and final state, after Rembrandt made considerable changes that focus attention on the drama of the event taking place.

ANTOINE WATTEAU (French, 1684–1721)

Study of Two Little Girls, ca. 1717–18

Black, red, and white chalk on buff paper; drawn over black chalk sketch of legs;
7⅜ × 9⅝ in. (18.7 × 24.5 cm)
Purchased by J. Pierpont Morgan, 1911; I, 278b

WATTEAU'S RAVISHING STUDY of two elegant young girls is a consummate example of his mature style of drawing in three colors (*trois crayons*), in which he uses his black, red, and white chalks with such assurance that they function almost as a single hue. The elder model—with her finely modeled profile—wears a string of pearls and looks rather vacantly to her right. Her younger companion, pert and lively, is portrayed resting her arms on a ledge and looking up with a quizzical, amused expression. Watteau uses delicate hatches of red and black chalks to indicate that her face is in shadow; the vibrancy of his mark-making conveys a sense of his model's inner life.

ANTOINE WATTEAU, *The Music Lesson* (*Pour nous prouver que cette belle*), ca. 1717–18. Oil on pine panel with walnut strips; 7⅜ × 9⅜ in. (18.6 × 25.7 cm) with added strips. The Wallace Collection, London.

It was Watteau's practice to draw from his models without a preconceived composition in mind; he kept his studies in bound notebooks and would use them to populate his paintings as and when they were required. The study of the little girl at right is preparatory for the foremost child at the center of *The Music Lesson*, from the Wallace Collection, London, who turns her head to listen to the gallant tuning his lute. Watteau does not appear to have used the study of the older girl in any of his paintings.

If you look very closely, you can see the black-chalk outlines of a pair of woman's legs in the background of the central section of the sheet, over which the two girls' heads have been drawn. The legs were only very faintly sketched in before being abandoned, and so it seems likely that Watteau made his studies of the two girls on a sheet of paper that he had already used and set aside.

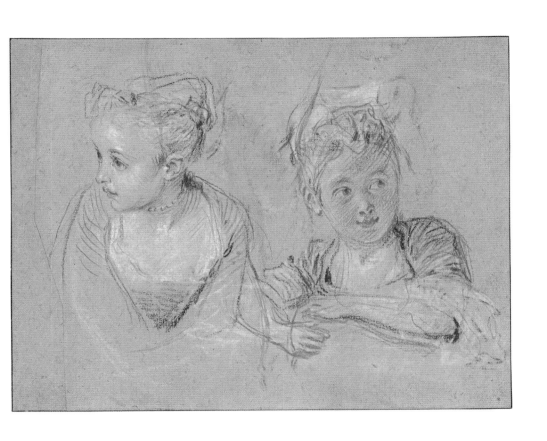

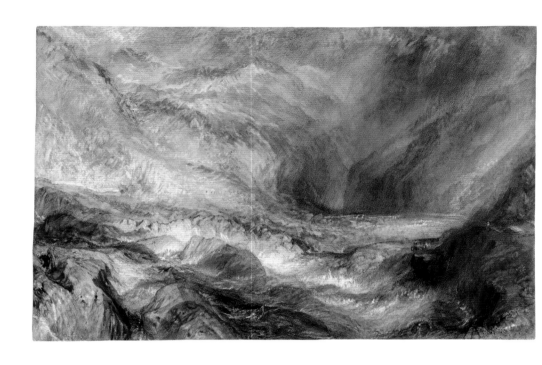

Joseph Mallord William Turner (English, 1775–1851)

The Pass of Saint Gotthard, near Faido, 1843

Watercolor over graphite; 11^{15}/$_{16}$ × 18^{1}/$_{2}$ in. (30.3 × 46.9 cm)
Thaw Collection; 2006.52

Until 1840, Turner's elaborate watercolor views were mainly produced to satisfy the thriving market for topographical prints. Demand shifted in the 1840s, and Turner then looked to private patrons to support this genre. Chief among these was the critic and author John Ruskin (1819–1900), whose first volume of *Modern Painters*, published in 1843, was a vigorous defense of Turner, above all in his truth to nature.

Returning from a visit to the Swiss Alps in August 1842, Turner worked up in his studio sample studies of the most significant sights he had observed, based on rough pencil sketches made on the spot. The melting of the ice at St. Gotthard's Pass near Faido, which turned the Ticino River into a torrent, was the subject of the sample study he presented to Ruskin, who commissioned the final watercolor, which Turner likely completed in the summer of 1843. Far more than the sample study, this large watercolor conveyed the tumult and energy of the roiling waters. Its horizontal format compresses the scene, reducing the amount of sky and truncating the mountain tops, to focus on the river's twisting torrents with the fearful rocks in the foreground. Human witness is indicated only by the tiny coach that turns the corner of the road above the jutting ledge of the mountain pass, in the lower right-hand quadrant of the composition, a detail easily overlooked.

The subject of Turner's watercolor is the terrifying, oppressive majesty of this Alpine range. Ruskin considered this drawing "the greatest work [Turner] produced in the last period of his art," and made at least three visits to Faido to contemplate the view that the artist had depicted.

PAUL CÉZANNE (French, 1839–1906)

Still Life with Pears and Apples, Covered Blue Jar, and a Bottle of Wine, 1902–6
Verso: *Landscape Sketch with Mont Sainte-Victoire and Trees*

Watercolor over graphite (recto and verso); 18 3/4 × 24 15/16 in. (47.6 × 61.7 cm)

Thaw Collection; 2002.61

THIS MAJESTIC, MONUMENTAL WATERCOLOR was painted in Cézanne's studio on the upper floor of the modest two-story house he built at Les Lauves, in the hills north of Aix-en-Provence, into which he moved in September 1902. The house was situated on a hillside offering superb views of Mont Sainte-Victoire, a subject Cézanne treated many times in the last years of his life, and which is depicted in the rudimentary sketch on the reverse of this drawing, abandoned early on. Turning his sheet of paper over, Cézanne now worked on this light-filled, stately composition of apples, pears, a covered jar, and a nearly empty bottle of wine arrayed on a large table. The lower third of the drawing is pure paper, untouched by any medium. We read this without difficulty as the top of the circular table that intrudes directly into the viewer's space. The table's far edge is set against an ill-defined but multicolored background, which might be read as a wall or window (at center and right) and a piece of furniture (at left). The entire composition is bathed in daylight.

Verso: *Landscape Sketch with Mont Sainte-Victoire and Trees.*

 Cézanne prepared the various elements of his still life in pencil, in vibrating lines that remain visible throughout under the washes of watercolor, generally applied in large sweeps and blended rhythmically. (Note, as examples, the blue enamel pot and the bottle of wine.) The apples in the center of the table, delineated in pencil, are given form by the creamy color of the paper itself, inflected by light touches of yellow and green watercolor. Many of the objects are also gone over in broken, semicircular strokes of blue in a technique associated with Cézanne's final years, adding to the energy that permeates the composition.

Eugène Atget (French, 1857–1927)

Cour de Rouen, 1898

Albumen print; 8 × 6¾ in. (20.3 × 17.2 cm)

Purchased on the Photography Collectors Committee Fund; 2015.46

Between 1898 and 1923 Atget made around a dozen different views of this secluded set of three interconnecting interior courtyards, tucked away behind Paris's busy Boulevard Saint-Germain. The Cour de Rouen (also known as the Cour de Rohan) incorporates elements dating back to the beginning of the thirteenth century. For Atget and his clients—two of whom, an illustrator and an engraver, lived in the Cour de Rouen—this picturesque and romantic site was all the more appealing in an era that had witnessed the rapid modernization and rebuilding of Paris. Atget had become a commercial photographer in 1890, providing source material to be used as "Documents for artists." In 1898 he embarked upon a series of around 2,500 photographs entitled *L'Art dans le Vieux Paris* (Art in Old Paris), documenting the remnants of Paris's historic architecture, sculpture, and decoration, as well as views of the streets themselves. His stock of pictures was acquired by the city's libraries, museums, and schools, as well as by historical and preservationist organizations. Interest in them was galvanized by the nostalgia for Paris's disappearing past.

Atget used a large-format wooden bellows camera, somewhat old-fashioned by this time, and glass plates with a general-purpose gelatin-silver emulsion, which required a relatively long exposure time. The black edges on the upper corners of this photograph are examples of optical vignetting, which resulted from Atget having repositioned the lens in relation to the glass plate in order to edit the perspective. In its mixture of aging brick and stone, weathered plaster, and abundant, almost ethereal, vegetation, this silent, unpopulated space does indeed appear as a site transfixed in time.

Edward S. Curtis (American, 1868–1952)
A Native American man on horseback, ca. 1910
Photograph on glass, hand-colored; 3½ × 4 in. (8.9 × 10.2 cm)
Archives of the Morgan Library & Museum; ARC 1176.223

Already a successful studio photographer in Seattle, in 1906 Curtis embarked upon *The North American Indian*—an extraordinarily ambitious photographic survey ostensibly documenting the traditional culture of every Native American tribe west of the Mississippi. Curtis's project involved the support of photographers, ethnographers, and research assistants. In addition to creating his richly photo-illustrated volumes and portfolios of photogravures, featuring subjects frequently posed by Curtis in a range of modern and historical costumes, he also collected ethnological data and made films and wax cylinder recordings of his subjects. In 1906 J. Pierpont Morgan pledged to cover expenses for Curtis's fieldwork for five years at the rate of $15,000 per annum. The project took twenty-three years and many more thousands of dollars to complete, with the twentieth—and final—volume appearing in 1930.

Morgan also insisted that Curtis raise funds to cover the publication costs of *The North American Indian*. To do so, Curtis created the multimedia *Picture Opera*, which involved projecting hand-painted lantern slides onto a wall or screen accompanied by Native American–inspired orchestral music, snippets of cinematic footage, and a lecture by the photographer himself. *The Picture Opera* debuted in New York in 1911 to generally enthusiastic reviews.

Of the seven hundred or so remaining lantern slides, the Morgan holds four hundred examples. Each of the roughly 3-by-4-inch lantern slides was made by reproducing an original dry-plate glass negative at a reduced size. Many of these were then colored by hand, in hues that had to be both vibrant and transparent enough to let light pass through the slide when it was projected for the performance.

DUANE MICHALS (American, b. 1932)

The Illuminated Man, 1968

Gelatin silver print, ed. 25/25; sheet: 20 × 23⅞ in. (50.8 × 60.6 cm)
Purchased on the Photography Collectors Committee Fund; 2018.37

BORN AND RAISED OUTSIDE PITTSBURGH, in McKeesport, Penn-
sylvania, Michals moved to New York City in 1956, and after
initially borrowing a friend's camera, he began working as
a professional photographer, shooting for magazines such
as *Esquire* and *Mademoiselle* in the early 1960s. His career as a
commercial photographer, employed on corporate ad cam-
paigns and by fashion magazines, developed in parallel with
his practice as an artist. In Michals's fine art photography,
he rebelled against the then-prevailing conventions of street
photography, conceiving his work in staged narrative or
poetic sequences, and often inscribing handwritten messages
or poems on his prints.

 The Illuminated Man shows fellow artist Theodore "Ted"
Titolo, a frequent model in these years, standing against a
dark background, his face and neck almost obliterated by
the bright light. Michals had discovered the tunnel on Park
Avenue between 39th and 42nd Streets, below Grand Central,
which would be flooded with shafts of sunlight at different
times of the day. He recalls going to the tunnel with his model
on a Sunday morning, when there was very little traffic, and
placing Ted so that the sunlight would land directly on his
face. Michals set his camera so that "the face would be way
overexposed and blur out on purpose." By manipulating the
effects of light and movement, combining words and images,
and using multiple images in sequence, Michals released the
metaphysical potential of his medium. "In *The Illuminated
Man*," the artist has noted, "I was asking, What if you could
see pure energy?"

THE ILLUMINATED MAN

Duane Michals 26/75

PETER HUJAR (American, 1934–1987)

Gay Liberation Front Poster Image, 1970

Gelatin silver print; image: 18½ × 12½ in. (47 × 31.8 cm)
Purchased on The Charina Endowment Fund; 2013.108: 1.76

PETER HUJAR, Gay Liberation
Front Poster, 1970. Courtesy John
Erdman and Gary Schneider.

A SURPASSING PORTRAITIST of New York's East Village art, music, and performance scene in the 1970s, Hujar explored gay sexuality in black-and-white photographs of uncompromising candor, eroticism, and tenderness. Before his death from AIDS-related pneumonia at the age of fifty-three, his work was known primarily by a small coterie of artists, writers, and critics. Hujar achieved recognition as a major figure in late twentieth-century photography only posthumously.

Of his art, he wrote that "Peter Hujar makes uncomplicated, direct photographs of complicated and difficult subjects." Politics was not his element, but he ventured into photographic activism to create a photo-based recruitment poster for the recently created Gay Liberation Front (GLF). The occasion was the first anniversary of New York's Stonewall uprising of June 1969, when the gay community had protested police violence. In the spring of 1970 Hujar assembled members of the group for an early morning shoot on 19th Street between Broadway and Fifth Avenue, not far from his studio. Taking an elevated position in the middle of the street, he asked everyone to run past him, up and down the block, as he stood and faced them. The cropping and compression of his image, conveying energy and engagement, were at odds with the relatively modest number of participants, seventeen in all, who ended up in the image. While *Gay Liberation Front Poster Image* has become one of Hujar's best-known works, this was not the case at the time. Most of the posters were stolen from the trunk of the car of a friend and fellow GLF member, who had been assigned the task of putting them up across the city.

EGON SCHIELE (Austrian, 1890–1918)

Portrait of the Artist's Wife Seated, Holding Her Right Leg, 1917

Gouache and black crayon on paper; 18¼ × 11⁹⁄₁₆ in. (46.3 × 29.4 cm)

Gift of Otto Manley; 1981.56

THIS IS A FRANK, AND IN SOME WAYS STARTLING, depiction of twenty-four-year-old Edith Harms, daughter of a retired master machinist on the Austrian railway, whom Schiele had married in June 1915. (He had met Edith and her sister Adele the year before; they lived across the street from his studio.) Schiele shows Edith seated on an invisible ledge, holding her right ankle in both hands, her left leg truncated just below the knee. With her tousled, strawberry-blonde hair, the sitter meets our gaze cautiously, perhaps even with hostility. She is shown wearing a crisp white blouse with a red ribbon at its collar, and a blue sweater cinched at the waist, but Schiele abandons all formality of dress in the lower half of his watercolor. Here we see the exposed flesh of Edith's thighs along with the red garters attached to her stockings and undergarments. Such details recall the far more sexually explicit drawings of women that Schiele had made earlier in the decade.

Although this is a finished watercolor, signed and dated "1917" in the tiny rectangular frame below her right shoe, it can be related to the oil portrait of Edith in Vienna's Galerie Belvedere that Schiele was working on during 1917–18. Decorous in its presentation, the painting shows his wife seated in a chair in a more conventional pose, her hands joined together on the armrest. This was the first oil painting by Schiele to enter an Austrian public institution during his lifetime. With the onset of the Great Influenza epidemic of 1918, Edith would succumb, six months pregnant, on October 28, 1918. Schiele died three days later, aged twenty-eight.

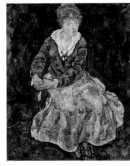

EGON SCHIELE, *Portrait of the Artist's Wife, Edith Schiele*, 1918. Oil on canvas; 55 × 43¼ in. (139.8 × 109.8 cm). Österreischische Galerie Belvedere, Vienna.

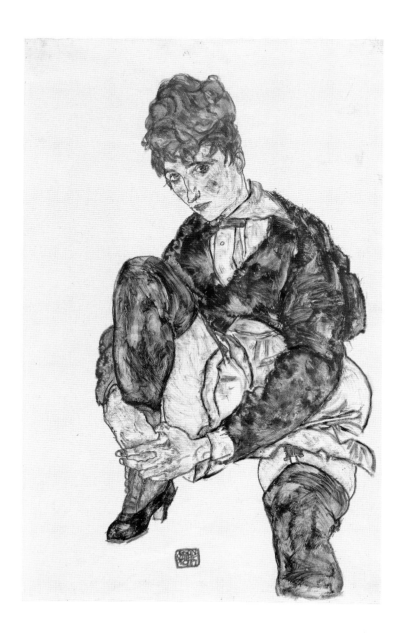

JUAN GRIS (Spanish, 1887–1927)

Man with Opera Hat, 1912

Black chalk on paper; 18¾ × 12⅜ in. (47.8 × 31.4 cm)
Thaw Collection; 2017.111

JUAN GRIS, *Man in a Café*, 1912.
Oil on canvas; 50¼ × 54¾ in.
(127.6 × 88.5 cm). Philadelphia
Museum of Art, The Louise
and Walter Arensberg Collection,
1950.

THIS RIGOROUS, METICULOUSLY CONSTRUCTED black-chalk drawing was preparatory for the large painting, *Man in a Café*, that Gris completed in August 1912 and exhibited two months later at the Salon de la Section d'Or at the Galerie la Boétie in Paris, the largest group exhibition of Cubist paintings held before the outbreak of the First World War. As the name of the Salon implies, these practitioners of Cubism—which did not include Picasso and Braque—were inspired by the ideal mathematical proportions of the Golden Section, a system of measurement dating back to antiquity. Gris, who had studied mathematics and the natural sciences, was also broadly familiar with the writings of Leonardo and Alberti. Having moved to Paris from Madrid in September 1906, he had been introduced to avant-garde artists and writers in Montmartre, and exhibited as a painter for the first time in 1912.

This is probably the first of two known preparatory studies of the man's head made for *Man in a Café*, and upon close inspection we can see multiple examples of Gris's erasures, where he rethinks and reworks the precise geometric forms that create the composition's overall structure. In this study, where the grids appear almost as fault lines, Gris pays close attention to the top hat worn by his dandified sitter, which is shown as both rectangular and cylindrical. He also conveys the man's physiognomy in fragments—his beady eyes and eyebrows, jaunty mustache, and bulbous nose—all of which remain immediately recognizable despite their distortions and dislocations. Notwithstanding Gris's fragmentation of form and his use of multiple viewpoints, the drawing achieves an almost classical stability and sense of order.

PABLO PICASSO (Spanish, 1881–1973)

Portrait of Marie-Thérèse Walter, July 28, 1936

Pen and black ink and wash on paper; 20⅛ × 13½ in. (51.1 × 34.3 cm)

Thaw Collection; 2006.58

THIS SOMBER, INTROSPECTIVE PEN-AND-INK portrait of twenty-seven-year-old Marie-Thérèse Walter was drawn on July 28, 1936, in the Parisian apartment that Picasso rented for his mistress. The date was inscribed by the artist in the upper left-hand corner of the drawing.

Perhaps as early as 1925—but certainly by 1927—the forty-four-year-old, married Picasso had met the teenaged Marie-Thérèse Walter (1909–1977), who lived with her mother and sisters in the suburbs of Paris. In January 1927 Picasso asked Marie-Thérèse to model for him, and the couple immediately embarked upon a tumultuous affair that would last for almost a decade. In the early 1930s, Walter was the model for many of Picasso's most erotic paintings of the female nude.

Marie-Thérèse gave birth to the couple's daughter, Maya, on September 5, 1935, and so was a young mother at the time this portrait was made. She is shown at a slight angle, with most of her face in shadow and her wide, saucerlike eyes looking out somewhat plaintively. Gray wash is used for the background and for most of her face. So intensely did Picasso apply his ink in certain places that over time it has bitten through the paper, notably at the tip of Marie-Thérèse's chin.

A fond and attentive father, Picasso was nonetheless preoccupied by the outbreak of the Spanish Civil War, which had been announced on July 18, 1936, ten days before he made this portrait. By the summer of 1936, Picasso was also tiring of his young mistress, and had started an affair with the Surrealist photographer Dora Maar. Despite this alienation of affections, Picasso portrayed Marie-Thérèse with a tenderness that reveals her vulnerability.

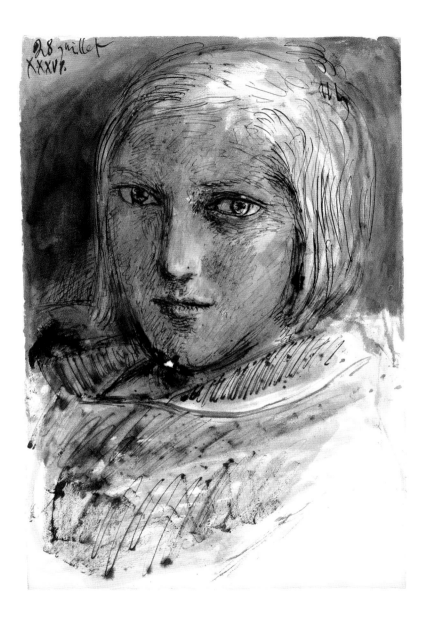

Martin Puryear (American, b. 1941)

Phrygian, 2012

Soft ground etching, drypoint, aquatint, and spit bite aquatint with chine collé;
image: 23¾ × 17⅝ in. (60.3 × 44.8 cm); sheet: 34¾ × 27⅝ in. (88.2 × 70.2 cm)
Published by Paulson Bott Press, Berkeley, Calif.
Anonymous gift in honor of Katharine J. Rayner; 2021.17

A SCULPTOR WHO ROSE TO PROMINENCE in the late 1970s and 1980s for his elegant and refined handmade wooden constructions, often of considerable scale, Puryear started making prints early in his career, notably between 1966 and 1968 when he was enrolled at the Royal Swedish Academy of Fine Arts in Stockholm. He returned to printmaking in 1999, and between 2001 and 2014 worked with the Paulson Bott Press in Berkeley, California, where he produced twenty-three etchings. In 2021 the Morgan acquired twenty of this series from Renée Bott, a master printer and cofounder of Paulson Bott Press, who had worked closely with Puryear on them.

MARTIN PURYEAR, *Big Phrygian*, 2010–14. Painted red cedar; 58 × 40 × 76 in. (147 × 101 × 193 cm), Glenstone, Potomac, Md.

Phrygian is a large, rather dramatic soft-ground etching that combines a range of different techniques, from drypoint to aquatint, to produce the rich, mottled background and powerful tonal qualities overall. The monumental form seems to float on the page and acquires a certain weightlessness. The conical, soft, red Phrygian cap was worn by freed slaves in ancient Rome and became a symbol of liberty during the French Revolution; it was also adopted by enslaved people struggling for their freedom in the Americas. Puryear explored the motif in his sculptures as well as in works on paper, but the relationship is a complex one. As he has noted, "I try to make works about the ideas in the sculpture without making images of the sculpture."

GEORG BASELITZ (German, b. 1938)

Untitled, December 7, 1984
Graphite and watercolor on paper; 25¹⁵⁄₁₆ × 18⅞ in. (65.9 × 48 cm)
Gift of the Baselitz Family; 2022.107

BASELITZ CAME TO INTERNATIONAL RECOGNITION in the 1960s and 1970s for his revitalization of figurative painting and drawing at a time when the avant-garde was dominated by abstract and conceptual art. In 1969 he took the momentous decision to paint his subject—or, as he prefers to call it, his motif—upside down, enabling him to work in the traditional genres without focusing on the psychology or meaning of his figures or landscapes. The two standing figures in *Untitled*, a man and a woman perhaps, are drawn first in quick, confident strokes of graphite over which watercolor is exuberantly applied. Following a method used by Picasso, an artist he esteems, Baselitz dated the drawing December 7, 1984, at lower right.

Baselitz has noted that the Norwegian artist Edvard Munch (1863–1944) was "one of his great favorites," and in the 1980s many of his works were inspired by Munch's paintings. In *Untitled*, the upright, standing figures, with their arms held close to their bodies, echo a type of presentation favored by Munch. Baselitz also uses multiple contours to outline and define his figures, an example of his fluid and fast-moving handling that owes much to the Norwegian's expressive style.

In early 2021 Baselitz informed the Morgan Library & Museum of his desire that the institution choose fifty works, spanning the entirety of his career, from the drawings that he had retained in his personal collection. The Albertina in Vienna, one of the largest and most important museums of prints and drawings, was also invited to choose fifty drawings, in tandem with the Morgan. This is among the most substantial gifts of drawings made by a living artist in the Morgan's history.

7.XII.84

Wangechi Mutu (Kenyan, b. 1972)

Untitled (Flower Series), 2016

Watercolor and ink on paper; 30 × 22⅜ in. (76.2 × 56.8 cm)

Gift of the Modern & Contemporary Collectors Committee; 2017.308

Mutu established her reputation in the early 2000s with large-scale collages of voluptuous if rather frightening figures—part human, part animal—that addressed issues of race, gender, and the contemporary African diaspora. Her work encompasses drawing, painting, and sculpture, as well as installation, video, and performance. In 2019 she created four bronze sculptures of seated female figures for the niches of the Metropolitan Museum of Art's historic facade.

This large, elegant watercolor, part of *The Flower Series*, was made in 2016 when Mutu returned from Brooklyn to her native Kenya after an absence of nearly twenty years and opened a studio in Nairobi. The spare format of the composition and concentration on what appear to be natural specimens are familiar aspects of traditional botanical illustration. However, while the spotted object in the center resembles a cowrie shell, the yellow substance oozing from its edge calls to mind the yolk of an egg, heightening the sensuality of the image.

Although inspired by Kenya's luscious flora and fauna, this still life merges the depiction of actual specimens with imaginary plants, creating a hybrid group that also evokes the female body. Mutu has pointed to the "inherent similarities of the human body and flowers," and noted that her mother, a nurse and midwife, had instilled in her a deep love of growing things from a young age. Mutu has also spoken about her "obsession with ink, solvents, liquids, paper and surfaces," which derives from her belief "in their live and organic qualities, as well as their associations with elements like blood, saliva, tears, sweat, and urine."

First published in 2024 by Scala Arts Publishers, Inc.
c/o CohnReznick LLP
1501 Avenue of the Americas, 10th floor
New York, NY 10019, USA
An imprint of B. T. Batsford Holdings Ltd.
In association with The Morgan Library & Museum

ISBN 978-1-78551-266-7

For Scala Arts Publishers, Inc.
Susan Higman Larsen and Claire Young
Designed by Patricia Inglis, Inglis Design
Printed in China

10 9 8 7 6 5 4 3 2 1

Image Credits
The Morgan apologizes for any unintentional omis-
sions and would be pleased to add an acknowledgment
in future editions: Album/Art Resource, NY: 78; © 2024
Georg Baselitz: 101; Photo © Brett Beyer, 2022: 2–3;
© Blaise Cendrars/Succession Cendrars, © Pracusa
20230412: 48–49; Photo by Janny Chiu: 33, 39, 42–44,
47–49, 51–52, 57, 65, 82–85, 93, 102; Photo by Steven
H. Crossot: 73; 75, 79–80, 94, 97; Photo by Francesco
del Vecchio: 74; Photo © Michel DENANCÉ, 2006: 6;
Image provided by DIAMM on behalf of Jane Austen's
Holograph Fiction MSS: A Digital and Print Edition:
53; Gabinetto Fotografico delle Gallerie degli Uffizi:
74; Photo by Carmen González Fraile: 68; Photo by
Graham S. Haber: front and back cover, front and
back flaps, 5, 8, 10, 12–13, 15, 17, 19–20, 23, 25–8, 30–31, 36,
40, 54, 59, 72, 76, 98; Courtesy John Erdman and Gary
Schneider. © Peter Hujar Archive, LLC, Courtesy Pace/
MacGill Gallery, New York and Fraenkel Gallery, San
Francisco: 90–91; Photo by Schecter Lee: 55–56; 64;
Photo by Erich Lessing/Art Resource, NY: 92; Photo
by Renée Lessing-Kronfuss/Orange: 92; Photo by
Jochen Littkemann, Berlin: 101; The Morgan Library &
Museum, ARC 5261: 4; © Wangechi Mutu, Courtesy the
artist and Gladstone Gallery: 102; © National Portrait
Gallery, London: 61; © 2024 Estate of Pablo Picasso/
Artists Rights Society (ARS), New York: 97; © Martin
Puryear, Courtesy Matthew Marks Gallery: 98–99;
Photo by Anthony Troncale: 67, 69, 71; Photo by Joseph
Zehavi: 24.

Library of Congress Cataloging-in-Publication Data:
Names: Colin B. Bailey, author | Title: Director's
Choice: The Morgan Library & Museum, in association
with Scala Arts Publishers, Inc. New York. Description:
Director Colin B. Bailey introduces the reader to The
Morgan Library & Museum's outstanding collection.
Identifiers: LCCN 2024957152 | ISBN 978 1 78551 266 7
(pbk.). Subjects: Art. Libraries. Museums. The Morgan
Library & Museum.

Acknowledgments
I am pleased to acknowledge the publications by
previous Morgan directors *In August Company: The
Collections of the Pierpont Morgan Library* (1993) and
The Morgan Library: An American Masterpiece (2000)
that introduced some of the many high spots in the
collection to a general public, a service that has been
vastly extended by the ever increasing offerings on the
Morgan's website, themorgan.org. This volume owes
much to the collaboration of the Morgan's curatorial
department heads, who reviewed my entries and made
helpful and timely revisions. The entire undertaking
would not have been possible without the participation
of Sarah Lees, Research Associate to the Director,
whose skills—both scholarly and organizational—kept
the project on track over a long gestation. Sarah and I
also thank our colleagues in Publications and Imaging
& Rights, Karen Banks, Ryan Newbanks, and Marilyn
Palmeri. Finally, I am grateful to Kristina Stillman,
Director of Finance and Administration, for encour-
aging me to embark upon this book.

—COLIN B. BAILEY